BLACK AND WHITE PHOTOGRAPHY

MANIFEST VISIONS / AN INTERNATIONAL COLLECTION JAMES LUCIANA

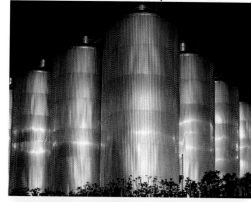

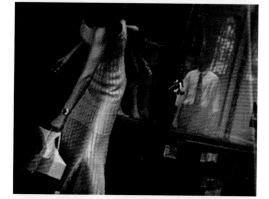

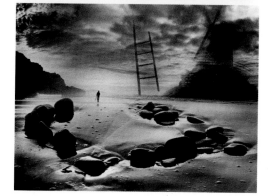

QUARRY

First published in the United States of America by:
Quarry Books, an imprint of
Rockport Publishers, Inc.
33 Commercial Street
Gloucester, Massachusetts 01930-5089
Telephone: (978) 282-9590
Facsimile: (978) 283-2742
www.rockpub.com

ISBN 1-56496-647-X

10 9 8 7 6 5 4 3 2 1

Designer: Rockport Publishers
Production: SYP Design & Production
Cover Design: Leeann Leftwich

Front Cover Images: (top) Jerusalem, Israel 1995 #112, Bruce Bennett, 16" x
16" (41 x 41 cm), Iris Print, 1995, *see page 128*; (middle) *Form and
Substance*, Olivia Parker, 16" x 20" (41 x 51 cm), Gelatin Silver Print, 1993,
see page 79; (bottom) *Untitled*, Jerry Uelsmann, 20" x 16" (51 x 40 cm),
Gelatin Silver Combination Print, 1998, *see page 71*

Back Cover Images: (left) Explorer, Robert Bennett, 10" x 12" (25 x 30 cm),
Gelatin Silver Print, 1992, *see page 7*; (right) *In God's Hand*, Joan Harrison,
14" x 11" (36 x 28 cm), Gelatin Silver Print, 1998, *see page 29*

Title Page Images: (top) From the series "Surface of the City," Masahiro
Oku, 9" x 11" (23 x 28 cm), Gelatin Silver Print, 1991, *see page 118*;
(middle) *Woman With Shopping Bag*, New York City, 1994, Don Lokuta,
13 1/2" x 18" (34 x 46 cm), Gelatin Silver Print, 1994, *see page 86*; (bottom)
Explorer, Robert R. Bennett, 10" x 12" (25 x 30 cm), Gelatin Silver Print,
1992, *see page 7*

Table of Contents Images: (top right) *Untitled*, Robert Kozma, 7 1/2" x 9 1/2"
(19 cm x 24 cm), Platinum/Palladium Print, 1995, *see page 43*; (top left)
Hooded Figure, Riverside Park, New York City, Leonard Speier, 14" x 17" (36
x 43 cm), Gelatin Silver Print, 1984, *see page 85*; (bottom left) *Eclipse-
Highland Pard*, Richard Margolis, 30" x 24" (76 x 61 cm), Gelatin Silver
Print, 1994, *see page 34*

Printed in China

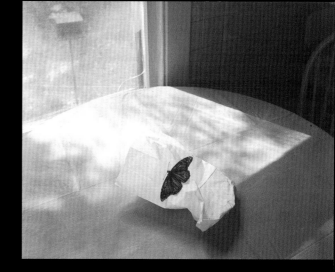

CONTENTS

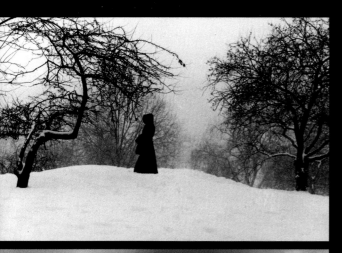

INTRODUCTION

In a most astonishing way, the images chosen for this book began to coalesce into a striking, cohesive group. Images began to play off one another, creating a resonance that I began to see as fantastic in the true sense of the word. Even images whose origins stemmed from a more straightforward tradition seemed somehow more powerful and enigmatic.

The images in this book point to one salient fact. Photographers evoking a clear and personal vision are alive and well in the culture of photography that continues today. These images make commentary on the nature of our world in a way that is not only intellectually engaging, but also visually joyful and powerfully moving. Whether viewing Flor Garduño's image of four lone figures carrying a child's coffin down a lonely street in the early morning fog of Tíxan, Equador, or Graciela Iturbide's *Mujer Angel* walking into the desert holding what appears to be a leash in one hand and a radio in the other, one is drawn to engage the image on many levels and to complete the circuit the photographer began by crafting the image initially.

The aesthetic decisions made by the photographer are many, and they play a part in the realization of a vision to be shared with others. In this book, the photographs, in all their modes of presentation, carry a message. That message is connected to the life work of the photographer and to that photographer's interests and commitments. The message is deeper than a single image. It conveys the photographer's life attitudes—a view for which I am indebted to photohistorian Bill Jay—and the nature of reality he or she wishes to portray. Whether we look at the enigmatic constructions of Vincent Serbin's mythical figures, or at Eric Lindbloom's image of a bicycle waiting forever in the early morning light, or at Linda Connor's *Tomb Doorway* that invites us to a world out of time, or at Jerry Uelsmann's evocative and almost timeless photographic blends, the marriage of that internal voice to the photographic process necessary to present it creates images that transcend either.

Images may continue to be personal evocations. But unless they transcend the individual who creates them, the images will forever remain anecdotal reminiscences that might be of interest but of little lasting value to those outside the anecdotal reference. One only has to look at Vince Cianni's image of handball players on a bright, hot, open court to realize that we do not really care what court it is or who the players are. The players transcend the specific court, and they become something far more—and perhaps different for each of us.

The photographers in this book care deeply about the power of the image to affirm, to educate, to bring awareness. They are concerned with what the photograph is about, not necessarily with what it is of. They evoke the spiritual nature of man, the wonder, the questions, the fear, and in some cases, the ritual remnants of our buried psyches.

With great delight I put this book together from various sources, the most satisfying of which was photographers who recommended other photographers. Initially envisioned as a simple collection to represent certain key catchalls—landscape, still life, portraiture, and similar titles—it rapidly veered into a terrain more difficult to define. With only one

image, or at best two images, to represent an artist's vision, I began to refine my criteria. I decided to select images from artists, not based on a single photograph, but on bodies of work that represented a strong and clearly defined aesthetic. To see within selected images a sense of the artist's vision and purpose became critical.

Richard Guggenheimer, in his book *Creative Vision*, observes that our present actually is composed of "a chain of rapid impressions producing a unified composition." He cites an example of an isolated impression: Mythical Person A closes his eyes and blinks them at Mythical Person B. What the viewer perceives is inconclusive and inadequate in order to determine the reality of what was actually occurring. The nuances of perception given by successive moments are missing.

During an artist's life, his/her peak experiences, creative insights, moments of cognition, and his/her representations of them all come together like Guggenheimer's concept of time composed of sequential moments unified by memory, until we are given not an isolated image, but a total impression—an intimate, coherent sense of that artist's vision and reality. There is continuity to that reality, one that can communicate and touch the lives of others. In its finest form, the photographic image, conventional or experimental, resembles remembered experience. If you try to remember, in full detail, the corner of your living room, you may not be able to do so. However, when you look up, everything snaps into place—just the way you remembered it. Well-resolved images may function in much the same way.

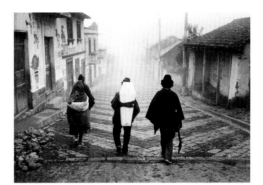

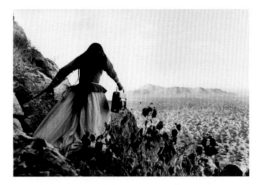

top: Camino al camposanto, Flor Garduño, *see page 133;*
bottom: Mujer Angel, Graciela Iturbide, *see page* 39

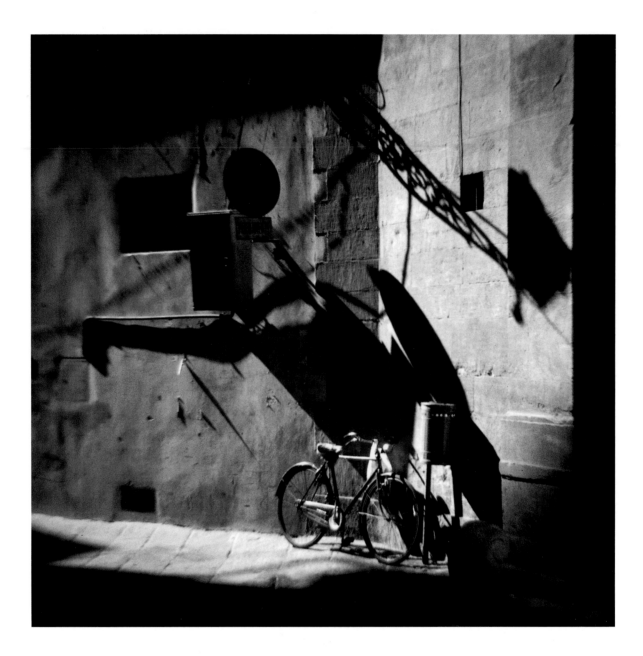

Bicycle, Near the Uffizi, Florence

Eric Lindbloom
7 ½" x 7 ¼" (19 x 18.5 cm)
Gelatin Silver Print 1981

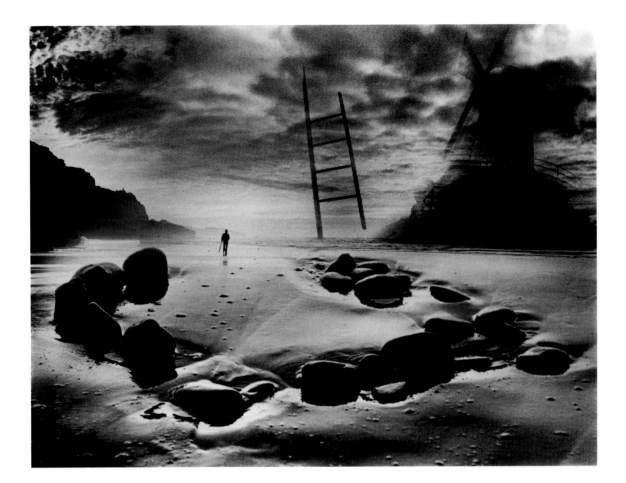

Explorer

Robert R. Bennett
10" x 12" (25 x 30 cm)
Gelatin Silver Print 1992

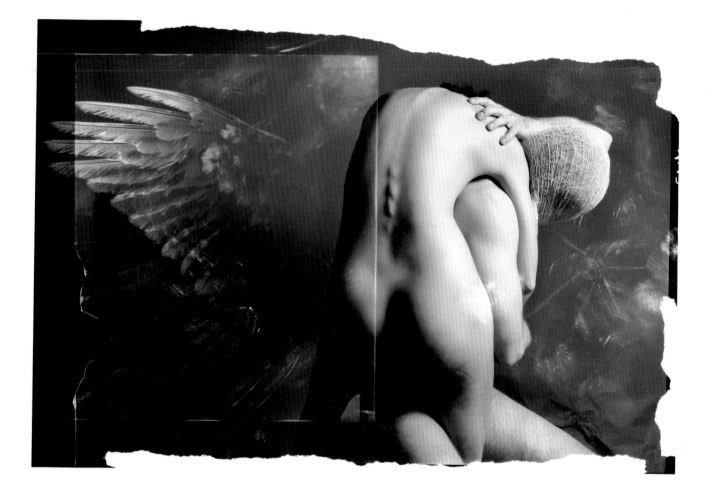

Negative Collage #19

Vincent Serbin
11" x 14" (28 x 36 cm)
Sepia-toned Gelatin Silver Print 1992

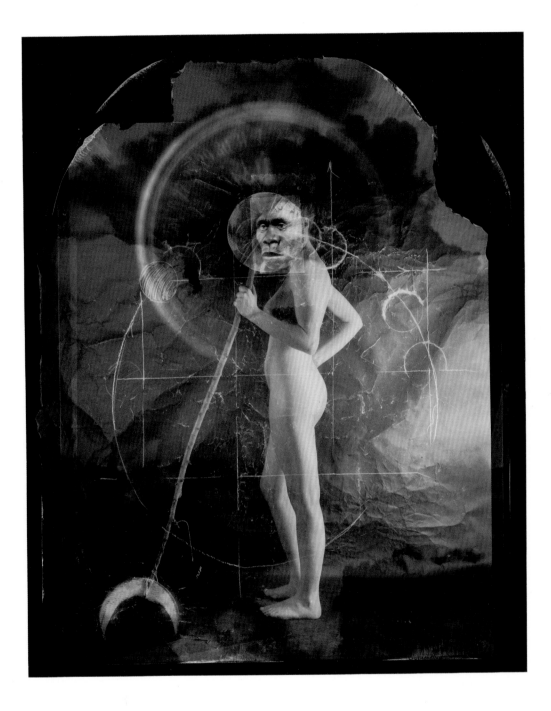

Monumental History

Vincent Serbin
14" x 11" (36 x 28 cm)
Sepia-toned Gelatin Silver Print 1995

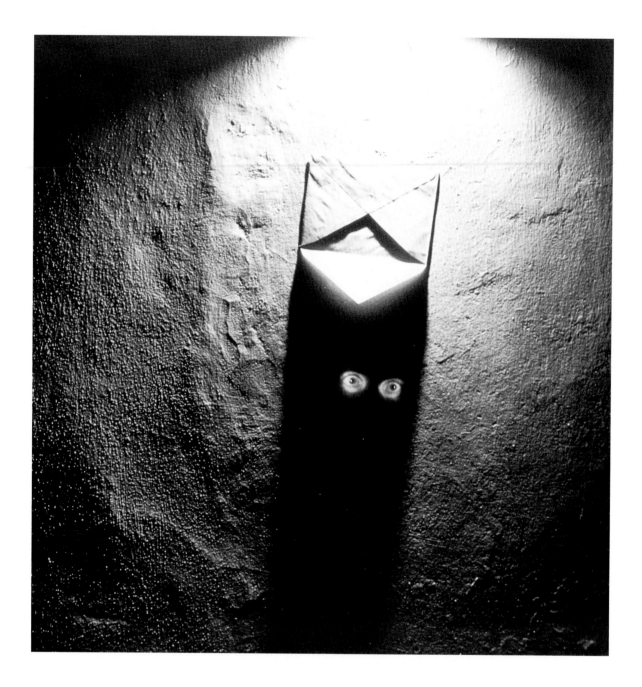

Para-Portraits #42

Kamil Varga
24" x 20" (60x 50 cm)
Gelatin Silver Print 1990

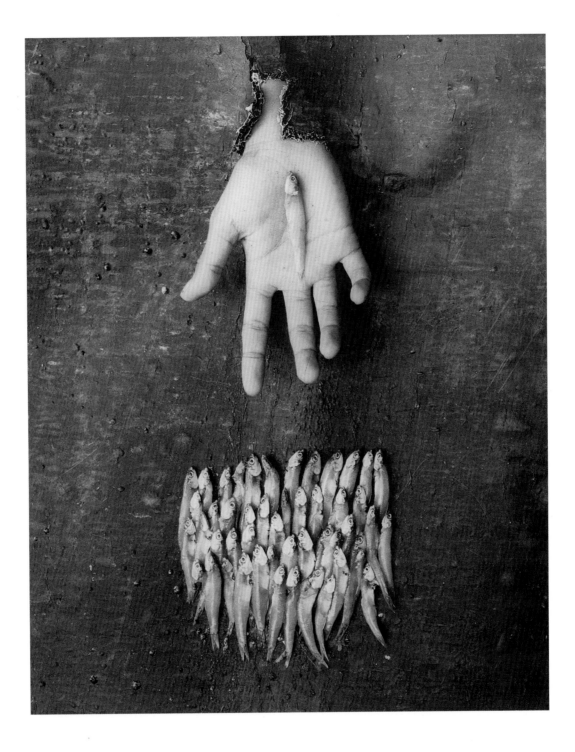

Solo tu cabes en la palma de mi mano

Juan Carlos Alom
20" x 16" (51 x 41 cm)
Gelatin Silver Print 1996
Throckmorton Fine Arts

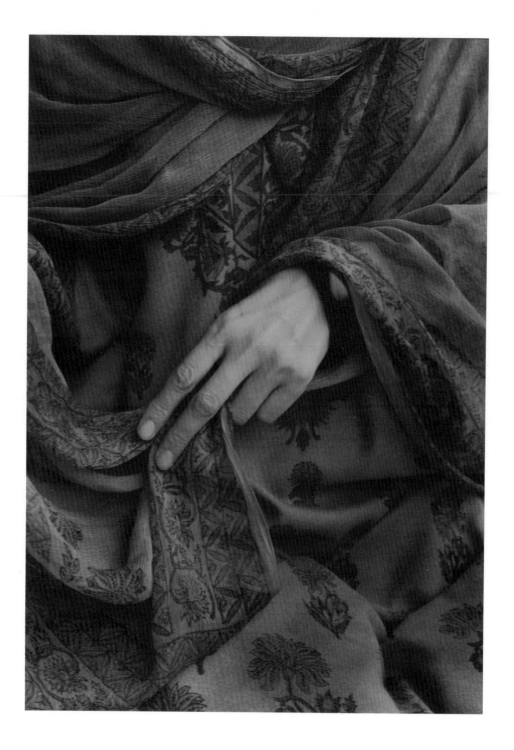

Her Hands #2

Tamaki Obuchi
8" x 5 ½" (20 x 14 cm)
Gelatin Silver Print/Black Tea Dyed 1998

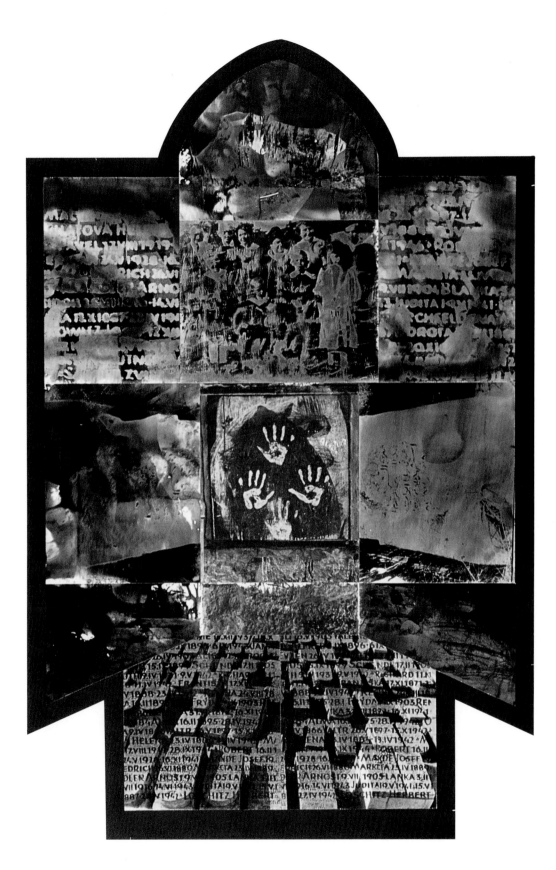

Canaan

Tatana Kellner
67" x 51" (170 x 130 cm)
Altered Silverprint 1992

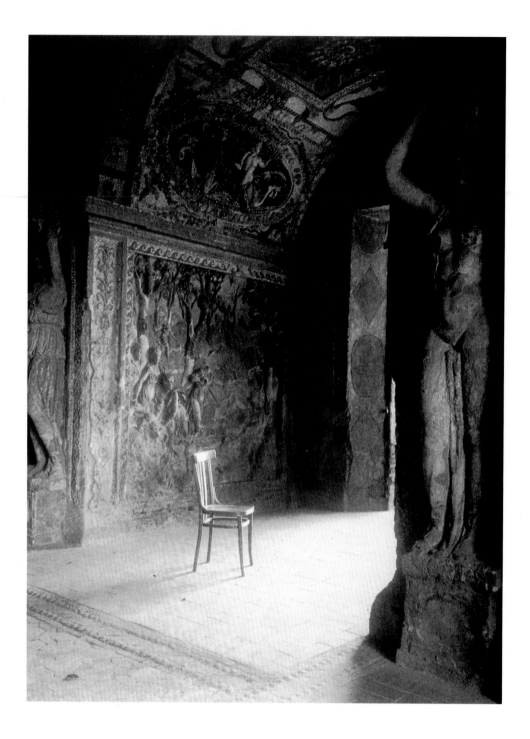

Diana's Grotto

Regina DeLuise
10" x 8" (25 x 20 cm)
Platinum/Palladium print 1994

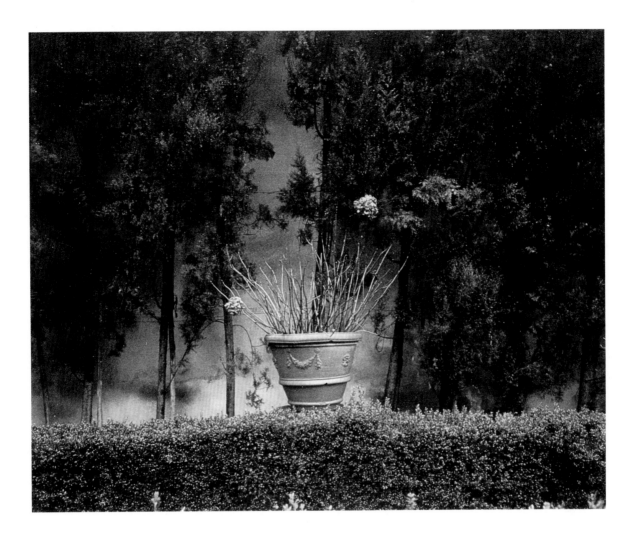

Vase, Villa Schifanoia

Regina DeLuise
8" x 10" (20 x 25 cm)
Platinum/Palladium print 1984

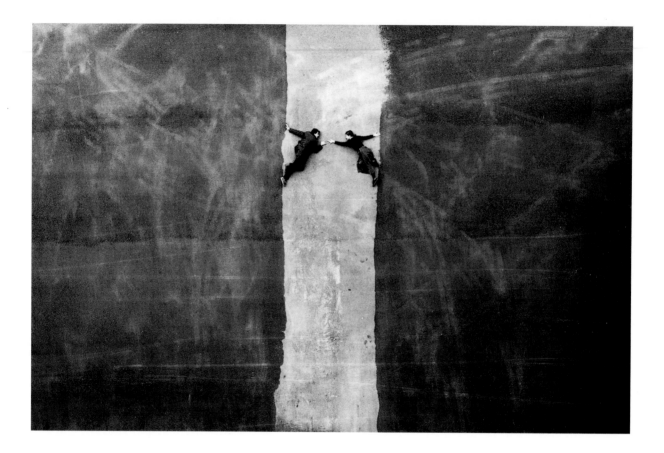

When I Returned Home

Miro Švolik
20" x 24" (50 x 60 cm)
Gelatin Silver Print 1986

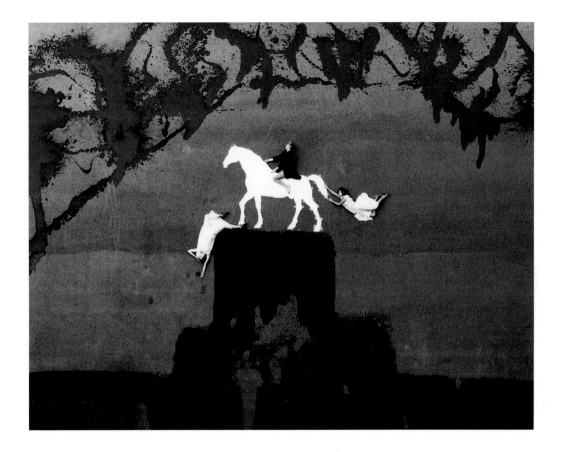

And on June 21 I Crowned Myself the Emperor

Miro Švolik
20" x 24" (50 x 60 cm)
Gelatin Silver Print 1986

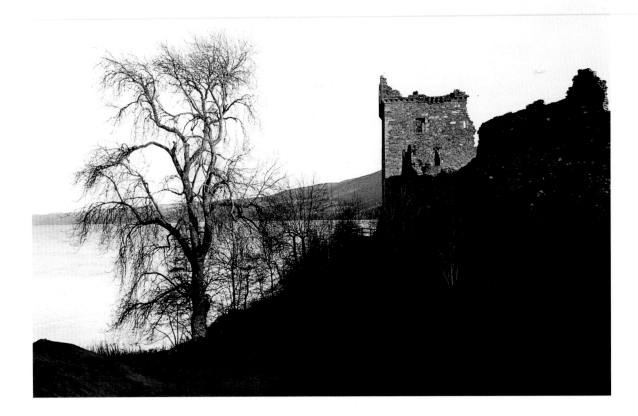

Urquhart Castle on Loch Ness, Scotland

David Emerick
16" x 20" (41 x 51 cm)
Toned Gelatin Silver Print 1997

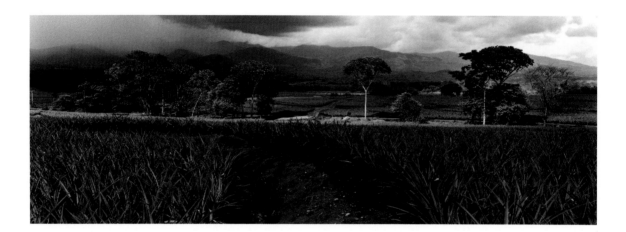

Storm Passing over Pineapple Plantation, Costa Rica

Joseph Vitone
7" x 22" (18 x 56 cm)
Gelatin Silver Print 1996

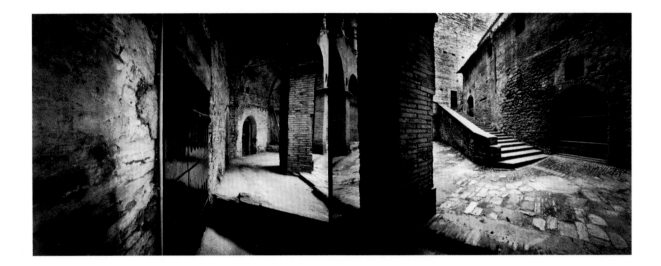

Pillared Courtyard

Craig Barber
8" x 20" (3 x 8 cm)
Platinum/Palladium Print 1992

Slowly the Future Comes into Focus

Craig Barber
7 ½" x 20" (19 x 51 cm)
Platinum/Palladium Print 1997

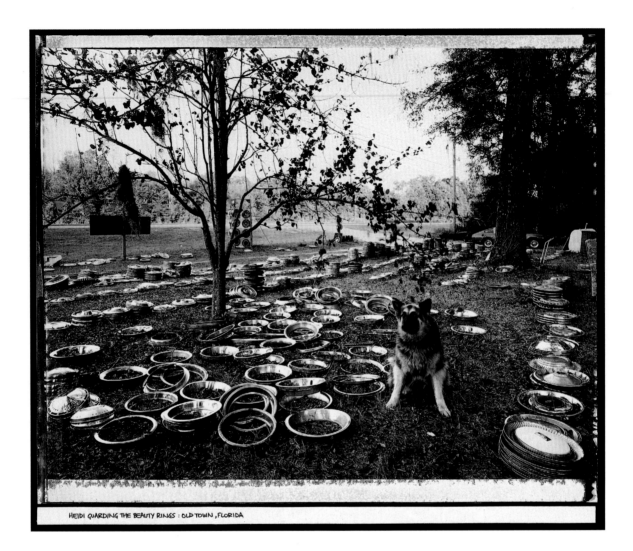

HEIDI GUARDING THE BEAUTY RINGS : OLD TOWN , FLORIDA

Heidi Guarding the Beauty Rings: Old Town, Florida

Jim Stone
20" x 24" (51 x 61 cm)
Gelatin Silver Print from Polaroid Negative 1984

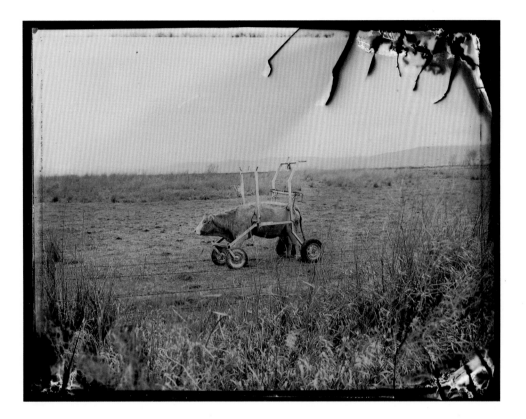

Injured Cow, Yakama Reservation, Washington

Drex Brooks
3 ¼" x 4 ¼" (8.3 x 10.8 cm)
Platinum-toned Gelatin Silver Print 1994

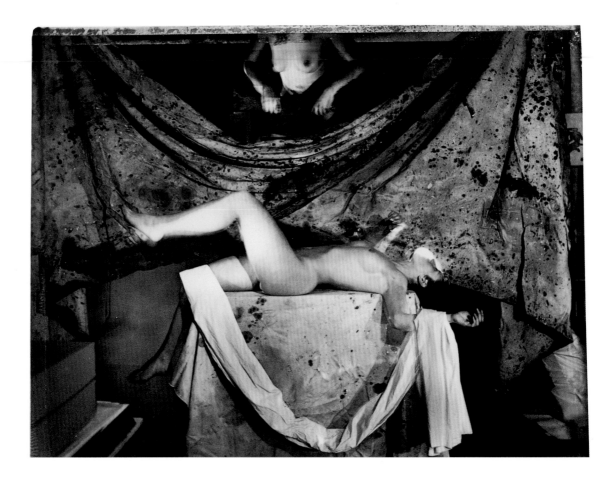

Untitled/Andover, MA

Siegfried Halus
16" x 20" (41 x 51 cm)
Gelatin Silver Print 1990

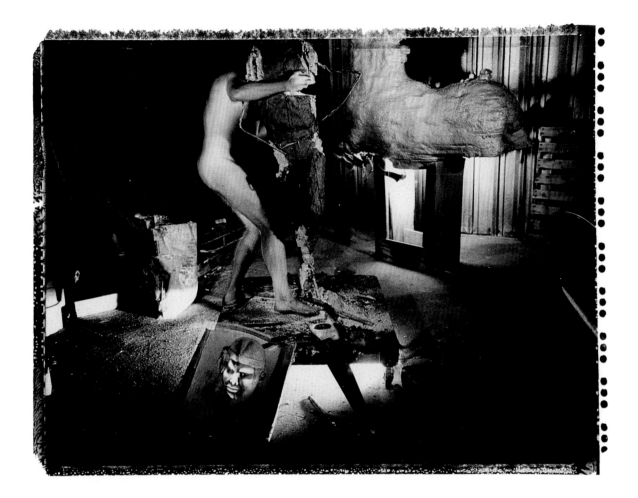

From the Foundry Series/Sante Fe, NM

Siegfried Halus
11" x 14" (28 x 36 cm)
Gelatin Silver Print 1995/95

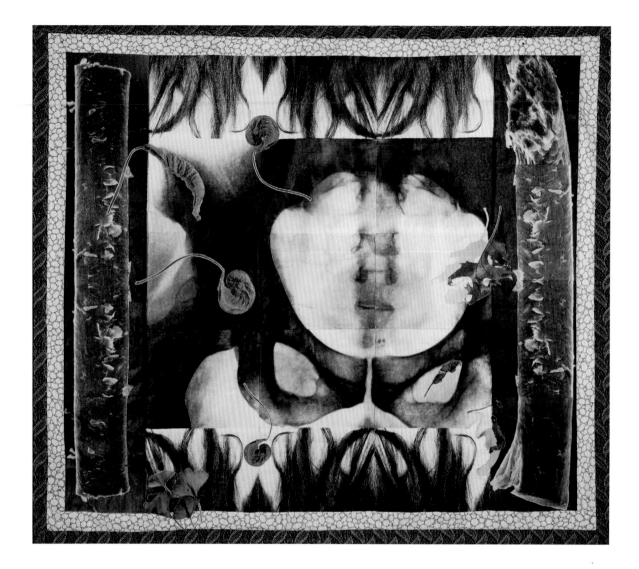

Follicular Quilt

Jeanette Claire Landrie
40" x 45" (102 x 114 cm)
Gelatin Silver Linen Print 1997

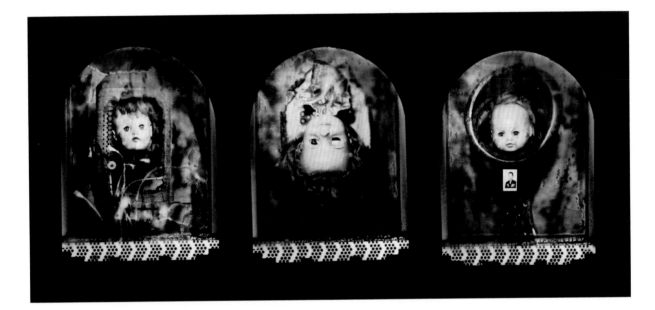

The Graces

Tom Santelli
8" x 16" (20 x 41 cm)
Photo Collage, Selenium-toned
Gelatin Silver Print 1998

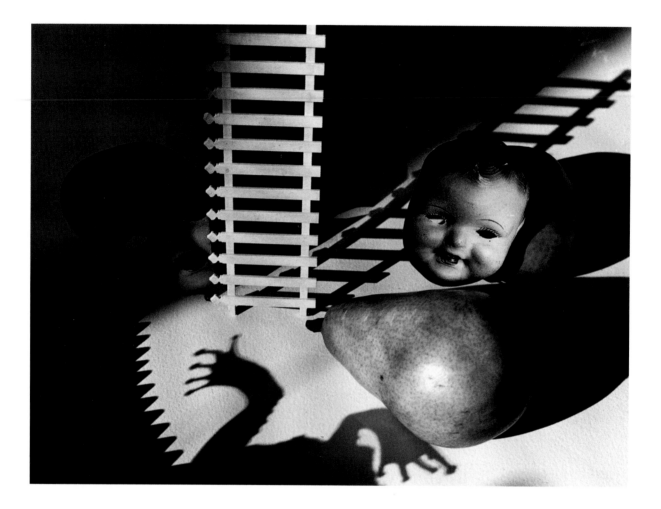

At the Circus

Joan Harrison
11" x 14" (28 x 36 cm)
Gelatin Silver Print 1998

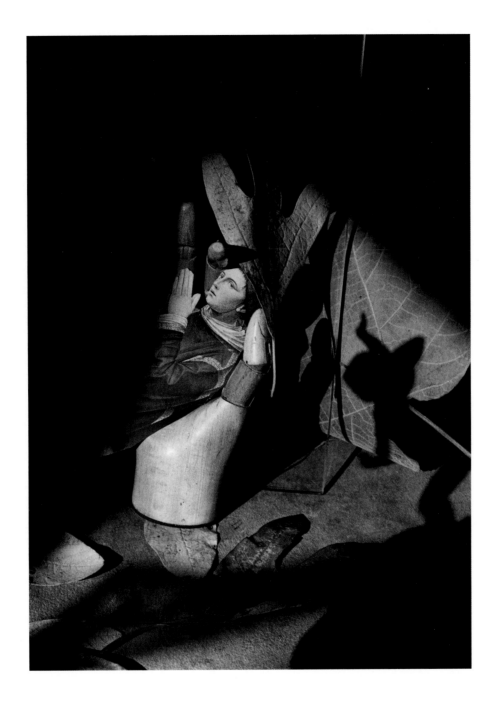

In God's Hand

Joan Harrison
14" x 11" (36 x 28 cm)
Gelatin Silver Print 1998

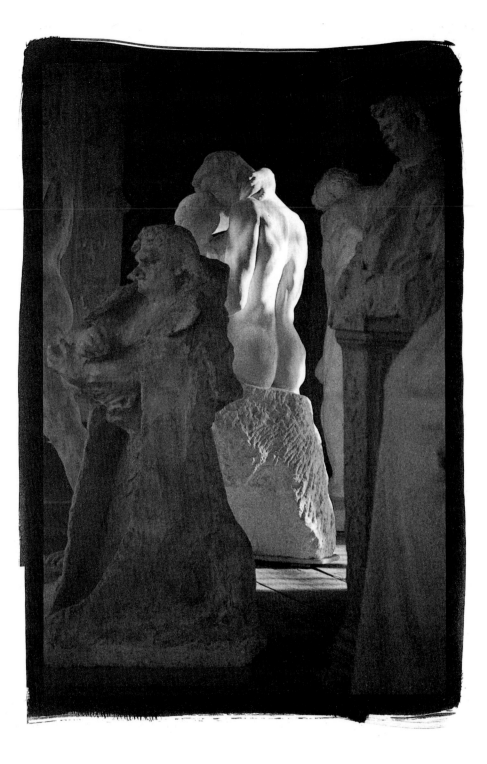

Vertical Kiss

Ernestine Ruben
14" x 11" (36 x 28 cm)
Platinum Print 1998

Aurora

Ernestine Ruben
14" x 11" (36 x 28 cm)
Platinum Print 1998

Uptown Panorama View from 22nd Street, NYC

George Forss
6" x 14" (15 x 36 cm)
Gelatin Silver Print 1993

Figure/Hand

Peter Goin
9 ⅜" x 12 ½" (24 x 32 cm)
Selenium-toned Silver Print 1994

Eclipse-Highland Park

Richard Margolis
30" x 24" (76 x 61 cm)
Gelatin Silver Print 1994

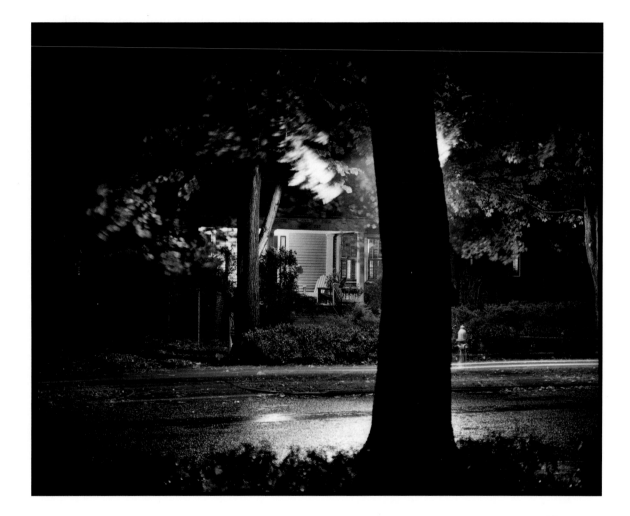

The View from My Porch

Richard Margolis
24" x 30" (61 x 762 cm)
Gelatin Silver Print 1992

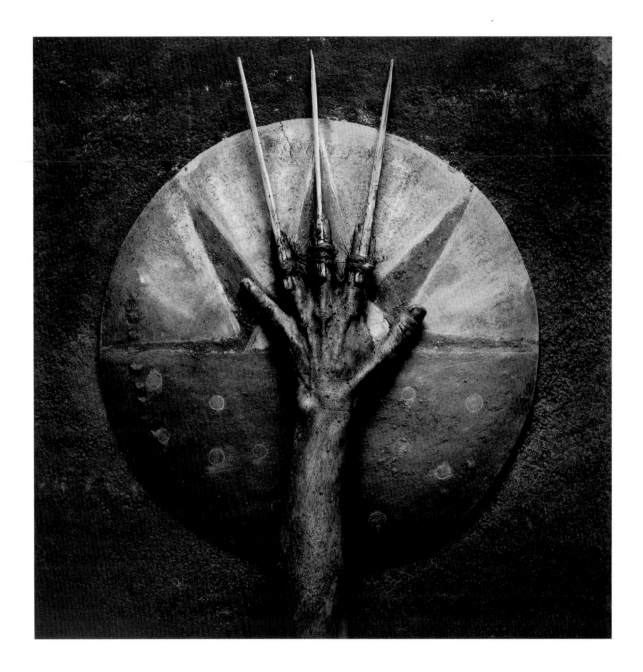

Tlapoyahua, Codices Series

Gerardo Suter
15" x 15" (38 x 38 cm)
Gelatin Silver Print 1991
Throckmorton Fine Arts

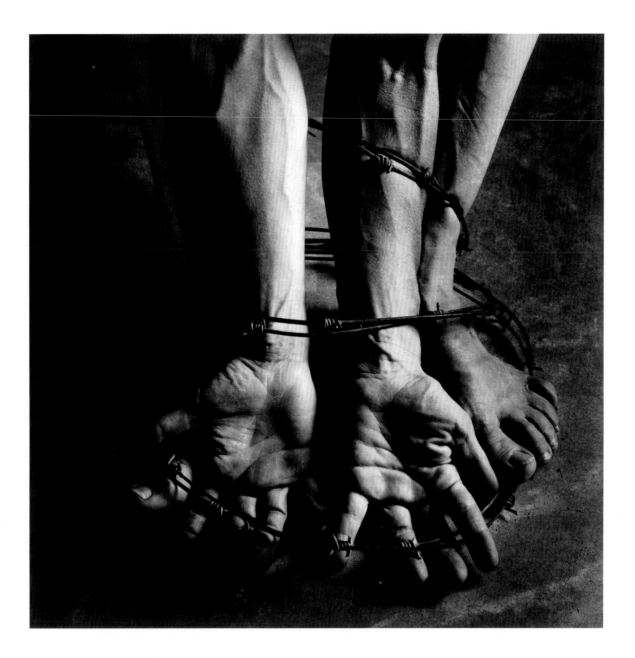

Arraigo—Rootedness

Gerardo Suter
35" x 35" (89 x 89 cm)
Gelatin Silver Print 1995
Throckmorton Fine Arts

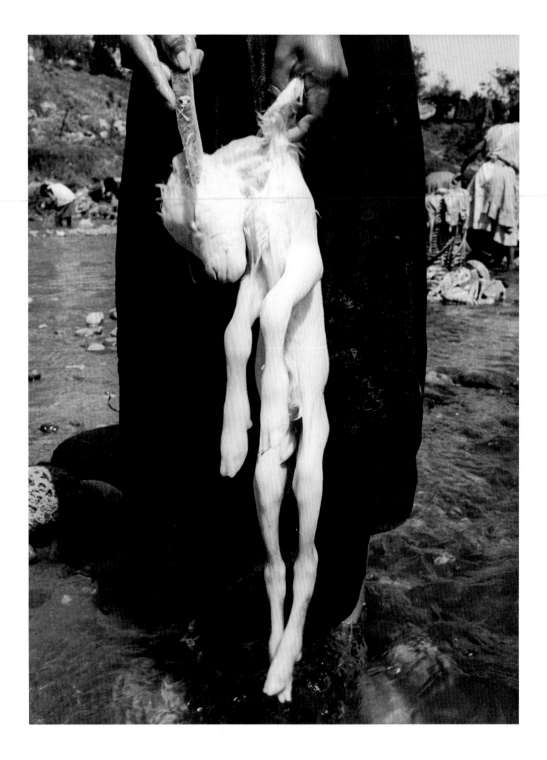

El Sacrificio

Graciela Iturbide
14" x 11" (36 x 28 cm)
Gelatin Silver Print 1992
Throckmorton Fine Arts

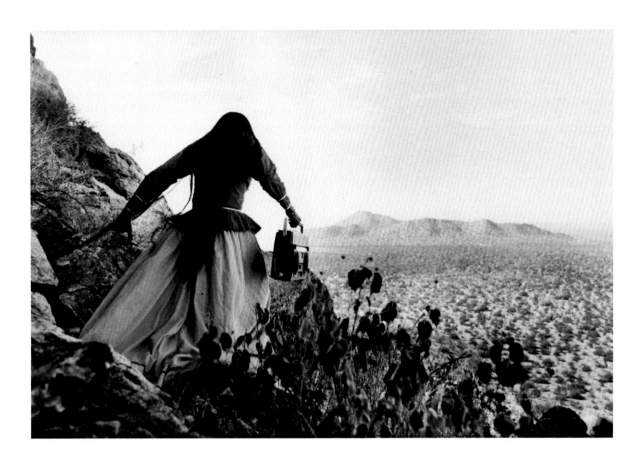

Mujer Angel

Graciela Iturbide
11" x 14" (28 x 36 cm)
Gelatin Silver Print 1980
Throckmorton Fine Arts

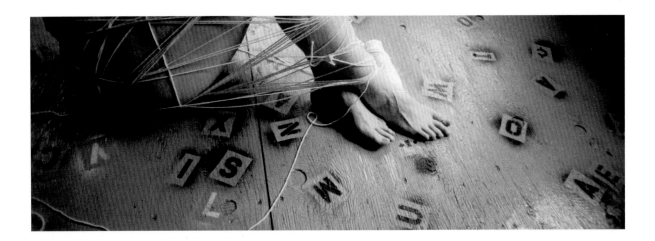

Self-Portrait in Studio

Susan Fowler-Gallagher
2 ¼" x 8" (7 x 20 cm)
Sepia-toned Gelatin Silver Print 1998

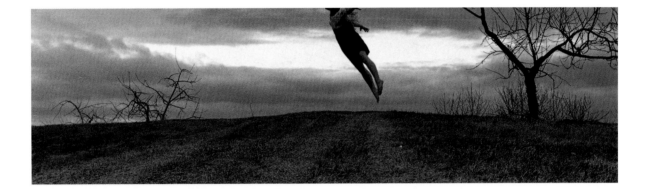

Untitled Self-Portrait #3

Anne Arden McDonald
3" x 10" (8 x 25 cm)
Selenium-toned Gelatin Silver Print 1986

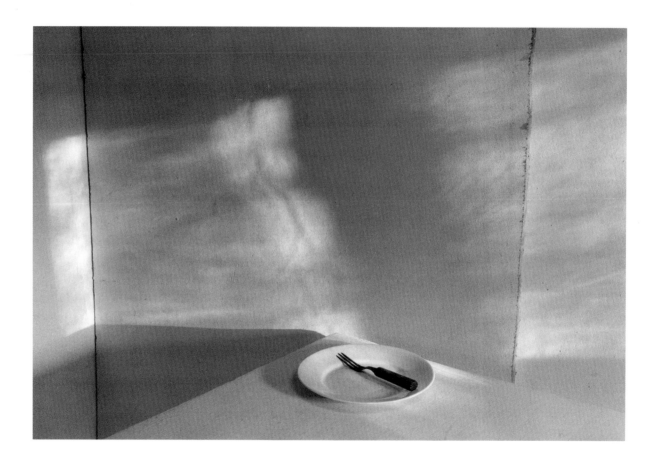

Fork

Lilo Raymond
11" x 14" (28 cm x 36 cm)
Gelatin Silver Print 1991

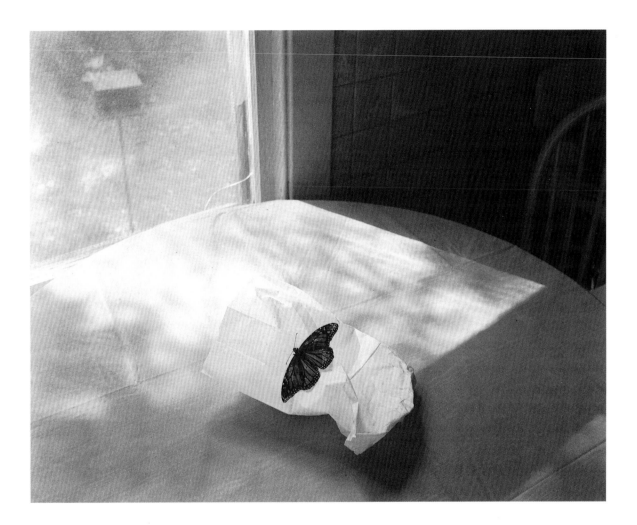

Untitled

Robert Kozma
7 ½" x 9 ½" (19 cm x 24 cm)
Platinum/Palladium Print 1995

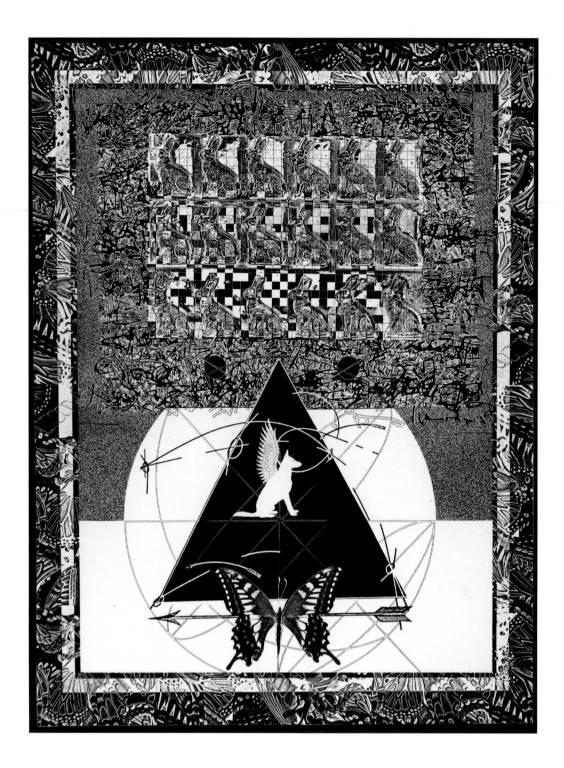

Winged Dog

J. Seeley
22" x 17" (56 x 43 cm)
Carbon-dusted Photo Lithograph 1994

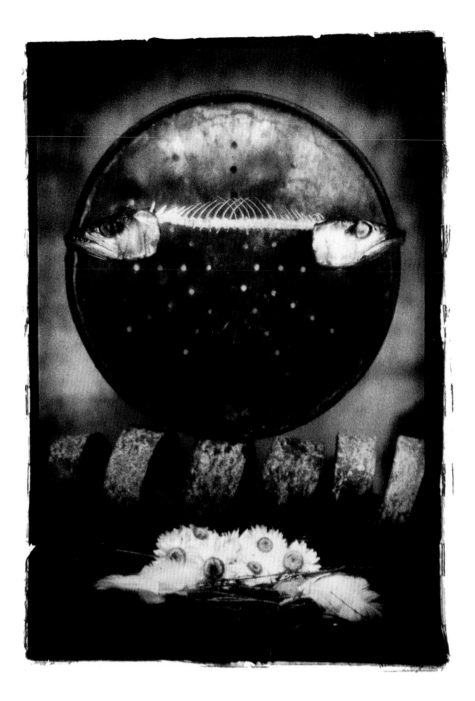

Totém u Tabú III

Gerado Montiel Klint
20" x 16" (51 cm x 41 cm)
Toned Gelatin Silver Print 1995

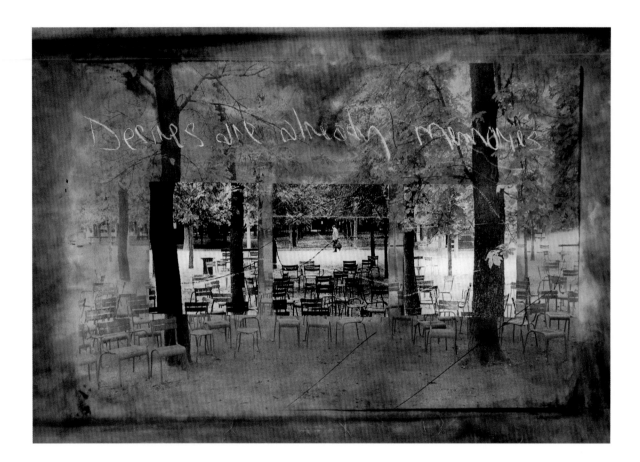

Desires Are Already Memories—for Calvino

Joe Marotta
40" x 60" (102 x 152 cm)
Silver Print with Oil Paint, Chalk 1997

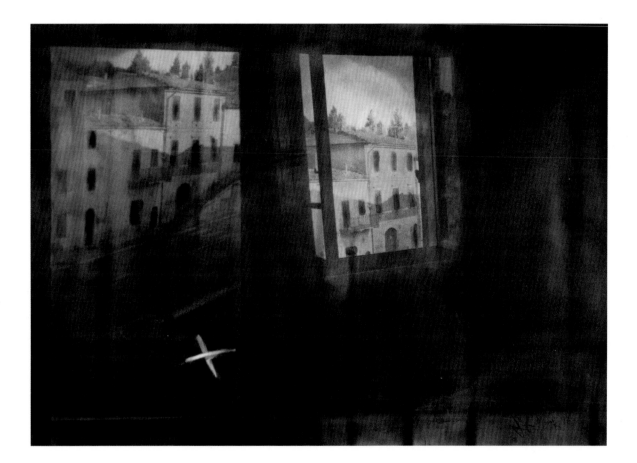

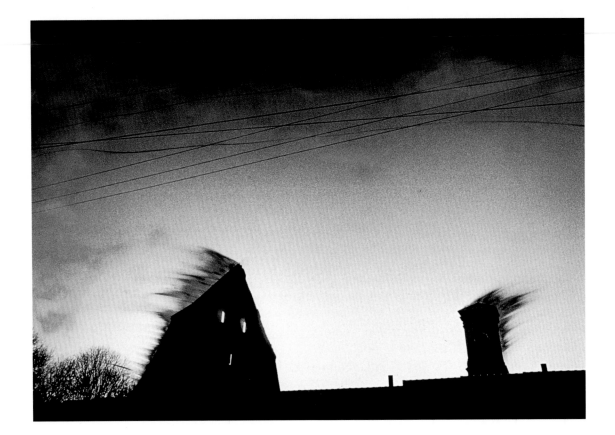

Conversing with the Wind

Peter Zupnik
16" x 23" (40 x 58 cm)
Gelatin Silver Print with Applied Color 1998

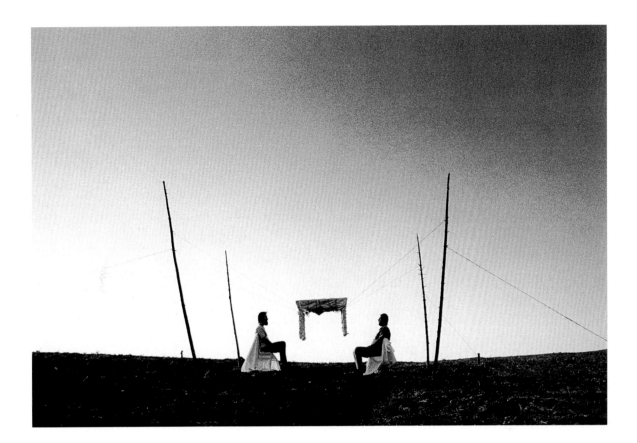

My Intuitive Theatre

Pavel Pecha
7 ½" x 11 ½" (19 x 29 cm)
Toned Gelatin Silver Print 1990

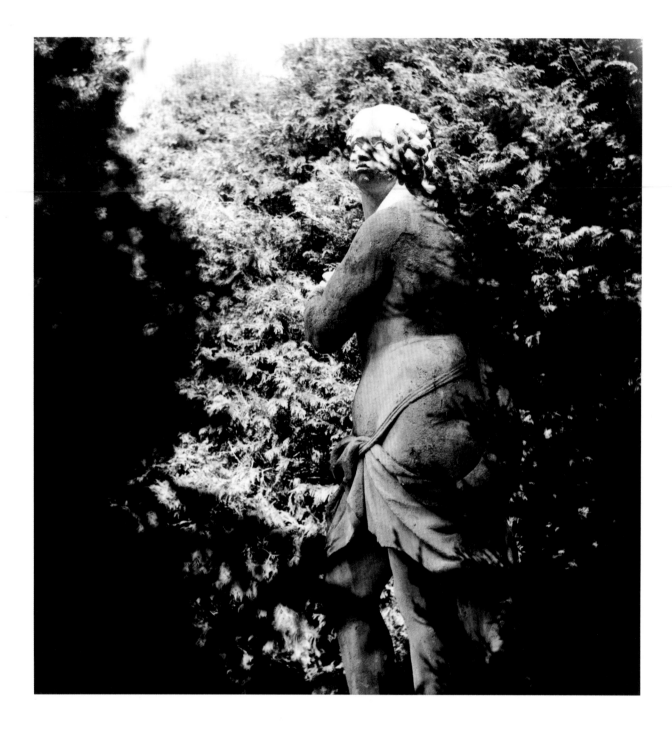

Secluded

Kathryn Hunter
9 ¼" x 9 ½" (23.5 x 24 cm)
Toned Gelatin Silver Print 1998

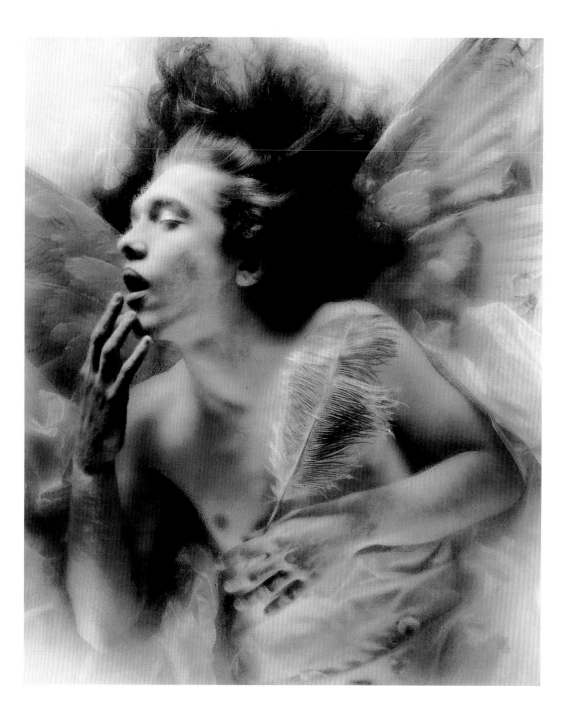

The Angel II

Václav Jirásek
19 ⅞" x 15 ¾" (50 cm x 40 cm)
Gelatin Silver Print 1993

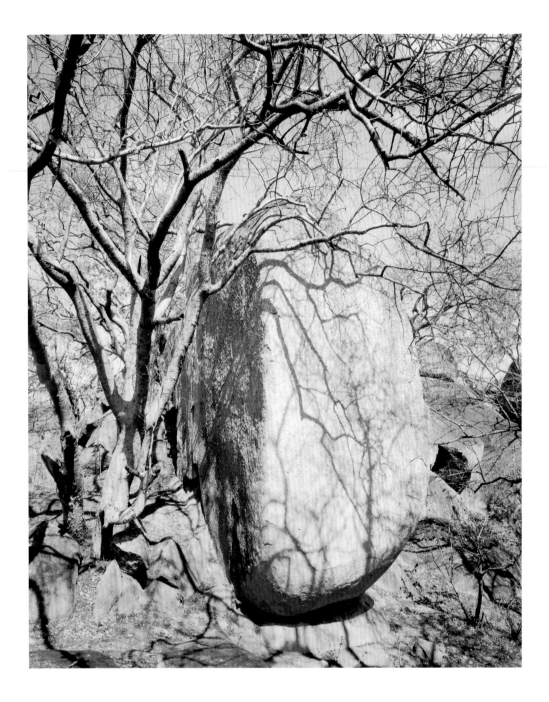

Stone with Shadows, Zimbabwe 1996

Linda Connor
12" x 10" (30 x 25 cm)
Printing Out Paper, Contact Print,
toned with Gold Chloride 1996

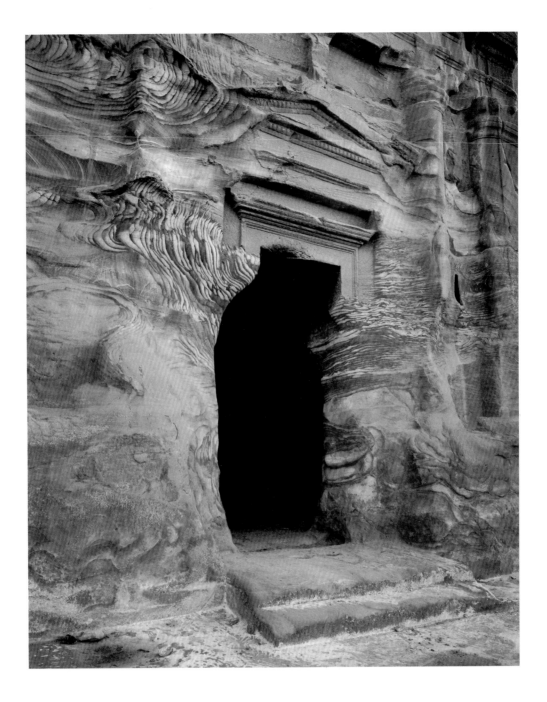

Tomb Doorway, Petra, Jordan 1995

Linda Connor
12" x 10" (30 x 25 cm)
Printing Out Paper, Contact Print,
toned with Gold Chloride 1995

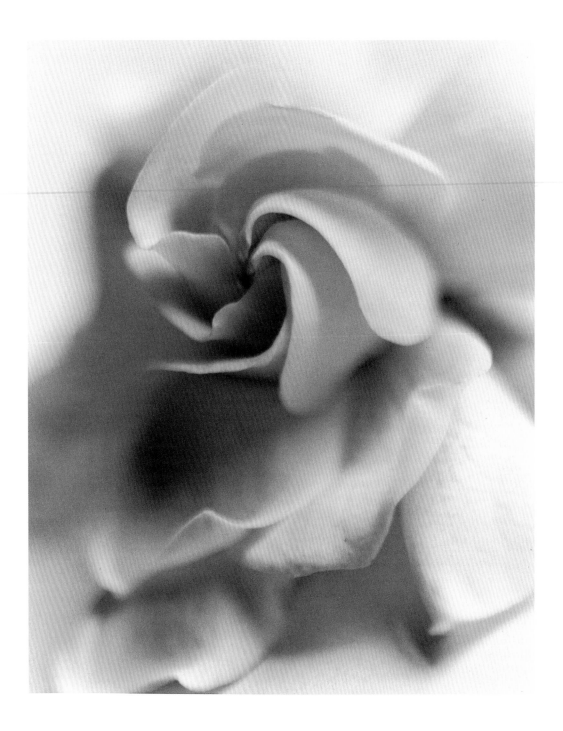

Gardenia II

Sandi Fellman
30" x 40" (76 x 102 cm)
Sepia-toned Gelatin Silver Print 1997
Edwynn Houk Gallery

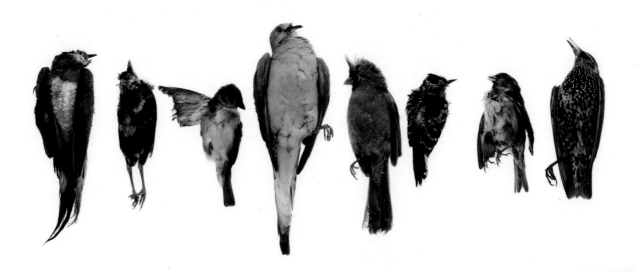

Specimen #23-2

Dick Lane
3 ⅞" x 9" (10 x 23 cm)
Toned Gelatin Silver Print 1999

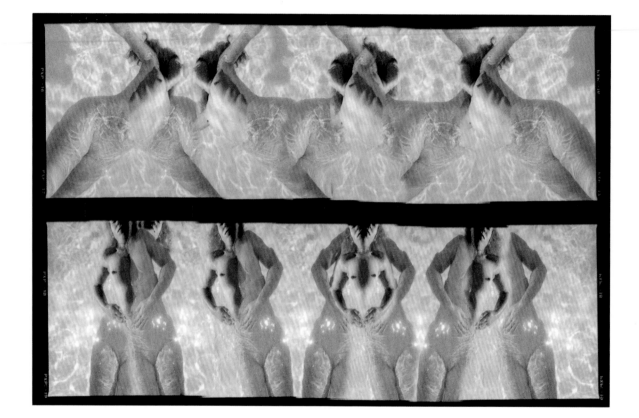

Linda

Dan McCormack
6" x 9" (15 x 23 cm)
Iris Print 1998

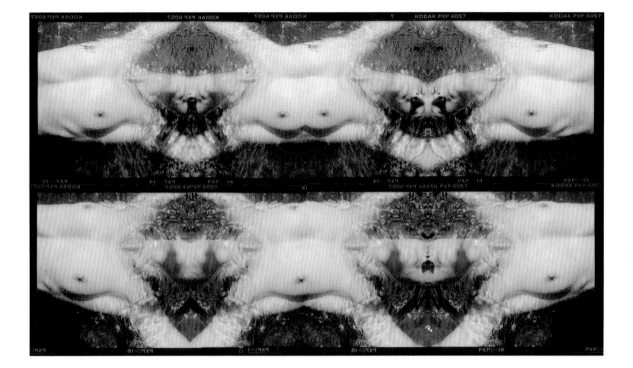

Nancy

Dan McCormack
5" x 8 ½" (13 x 22 cm)
Iris Print 1998

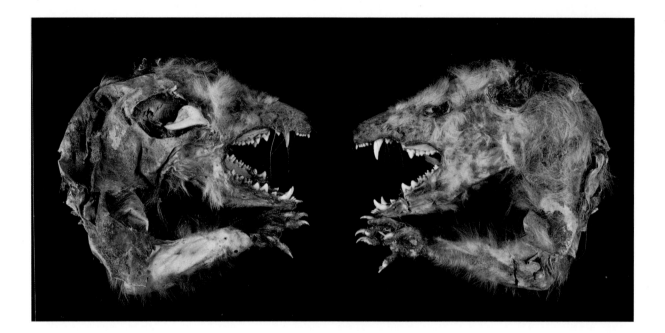

Coloma to Covert Marsupial #2

Barbara Crane
30" x 50" (76 x 127 cm)
Gelatin Silver Print 1996

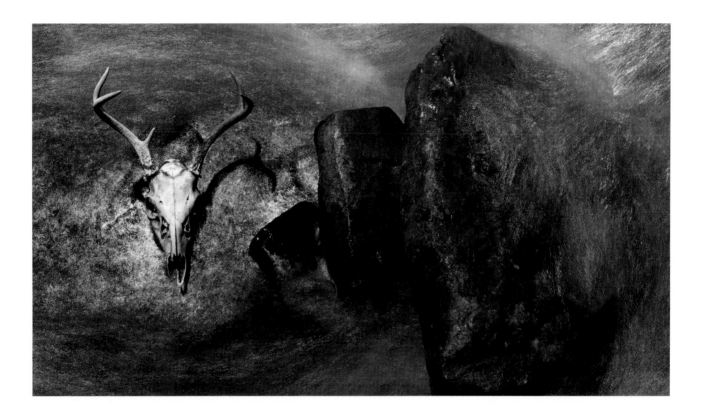

Adirondack Study

Roger Arrandale Williams
12" x 20" (30 x 51 cm)
Gelatin Silver Print 1998

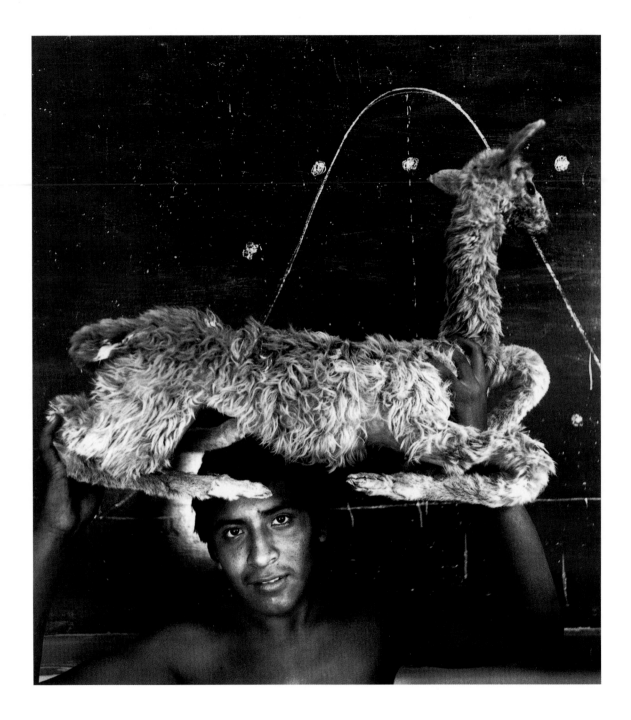

La Llama, Ayacucho, Peru

Javier Silva Meinel
15" x 15" (38 x 38 cm)
Gelatin Silver Print 1994
Throckmorton Fine Arts

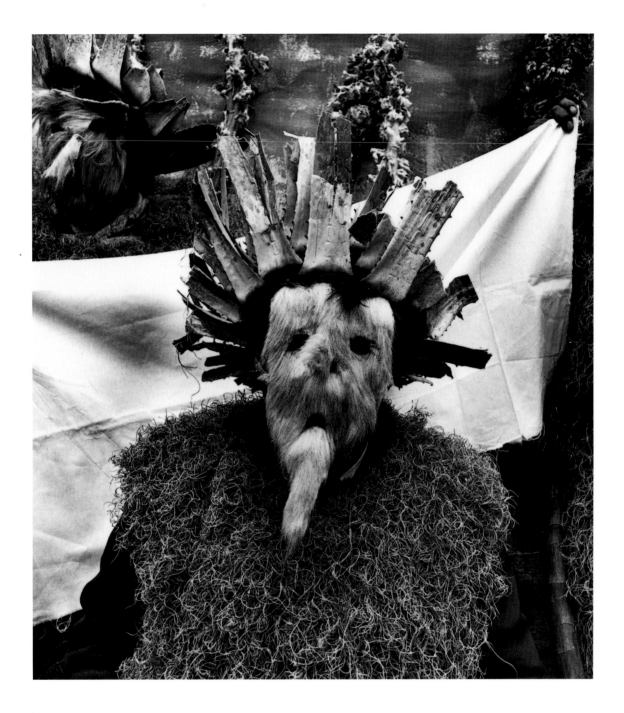

Hombre Cactus, Qollor Riti, Cuzco, Peru

Javier Silva Meinel
15" x 15" (38 x 38 cm)
Gelatin Silver Print 1993
Throckmorton Fine Arts

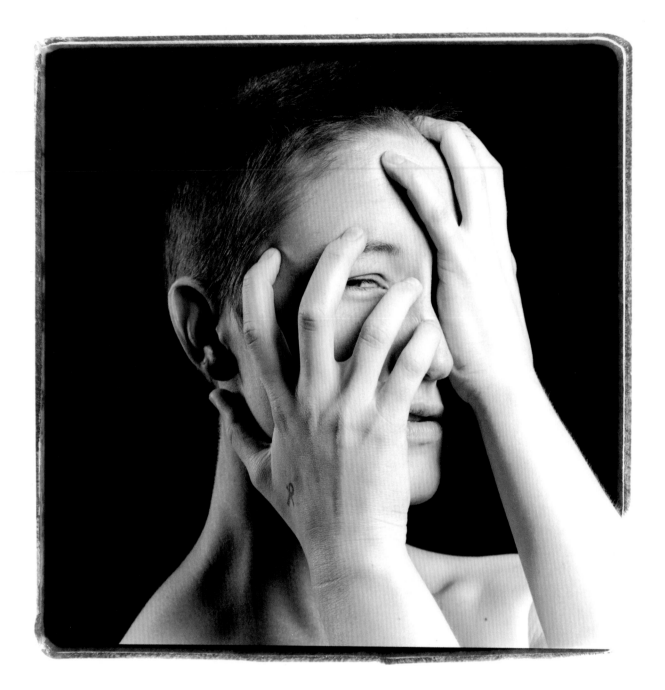

From **A Woman's Ire**

Will Faller
10" x 10" (25 x 25 cm)
Toned Gelatin Silver Print 1997

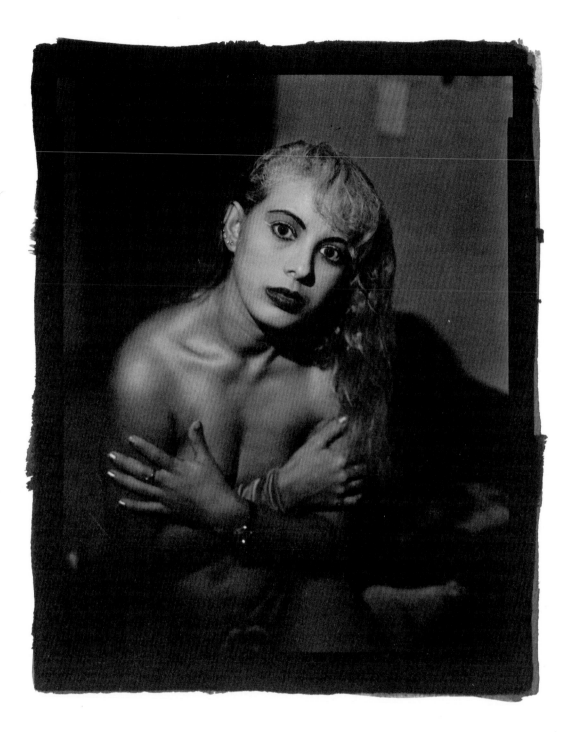

Vanessa

Steve Weisberg
10" x 8" (25 x 20 cm)
Platinum Print 1998

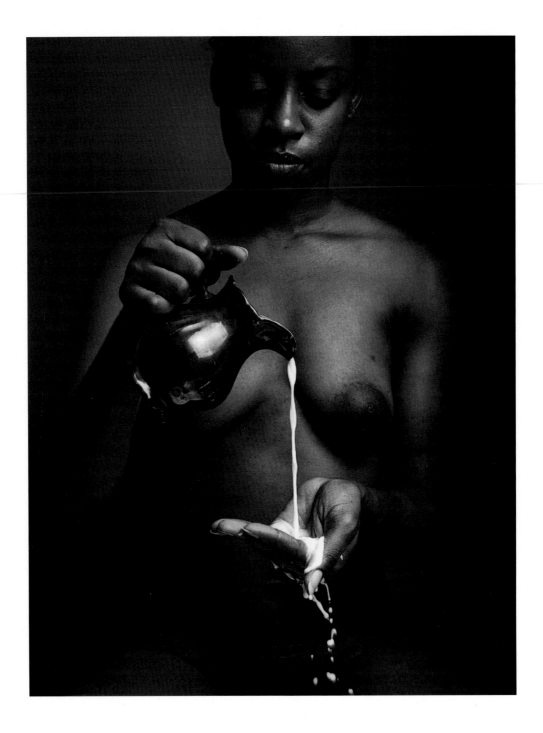

Spilt Milk

James Riegel
10" x 8" (25 x 20 cm)
Selenium-toned Gelatin Silver Print 1991

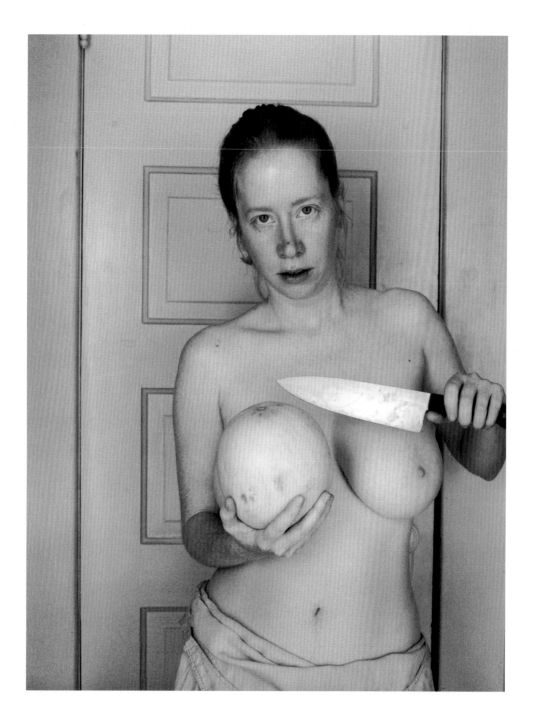

Melon Hostage

James Riegel
10" x 8" (25 x 20 cm)
Selenium-toned Gelatin Silver Print 1991

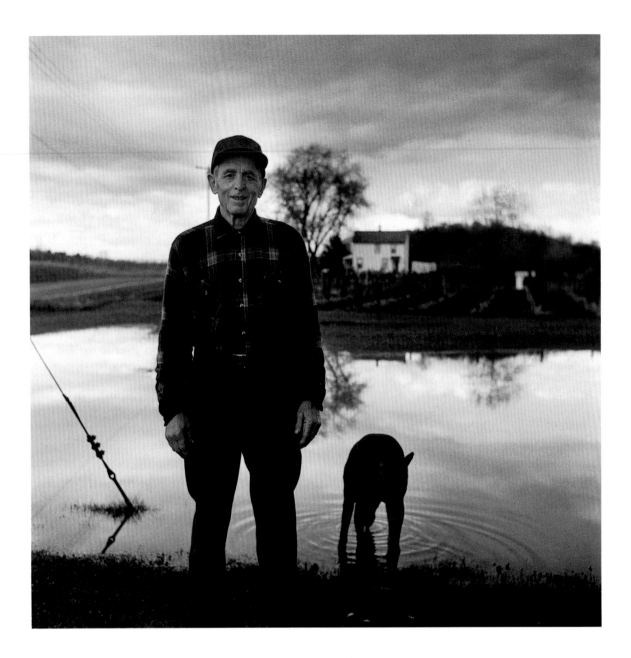

Primo

Ken Shung
11" x 14" (28 x 36 cm)
Gelatin Silver Print 1989

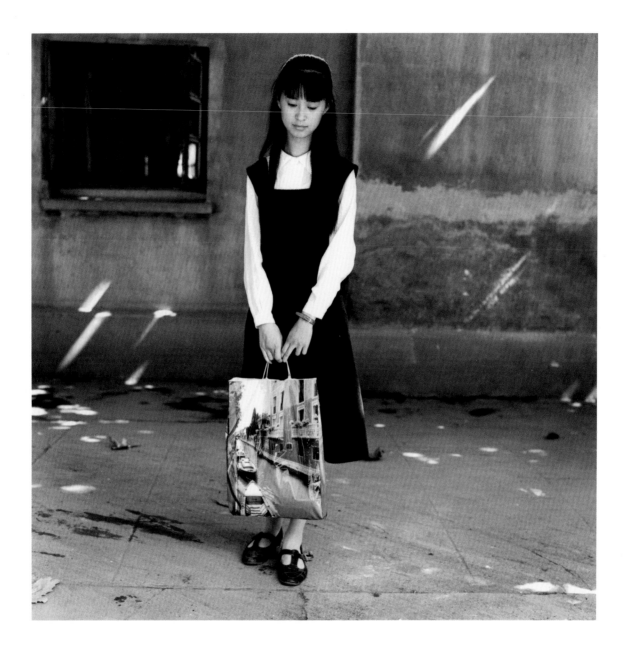

Young Woman, Nanjing, P.R. China

Martin Benjamin
14" x 14" (36 x 36 cm)
Gelatin Silver Print 1993

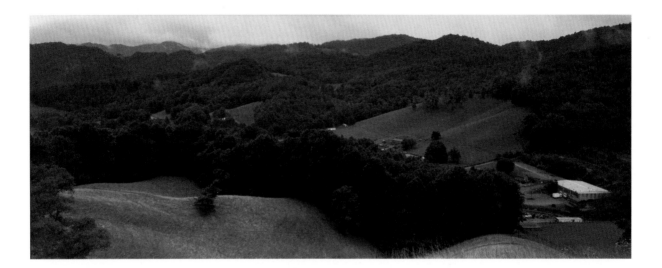

Valle Crucis, NC

John Scarlata
7" x 17" (18 x 43 cm)
Gelatin Silver Contact Print 1992

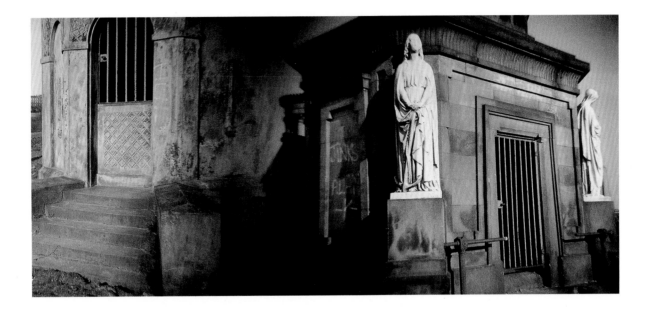

The Necropolis, Glasgow, Scotland, #2104

Ardine Nelson
15 ½" x 34" (39 x 86 cm)
Handcolored Gelatin Silver Print 1996

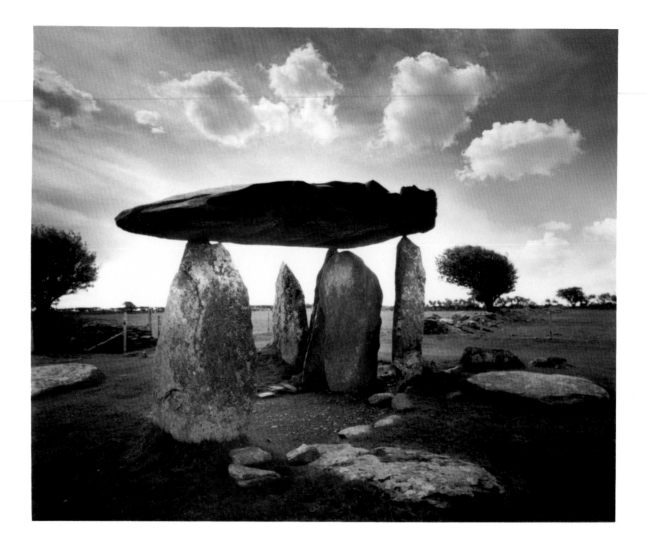

Untitled

Jerry Uelsmann
16" x 20" (40 x 51 cm)
Gelatin Silver Combination Print 1996

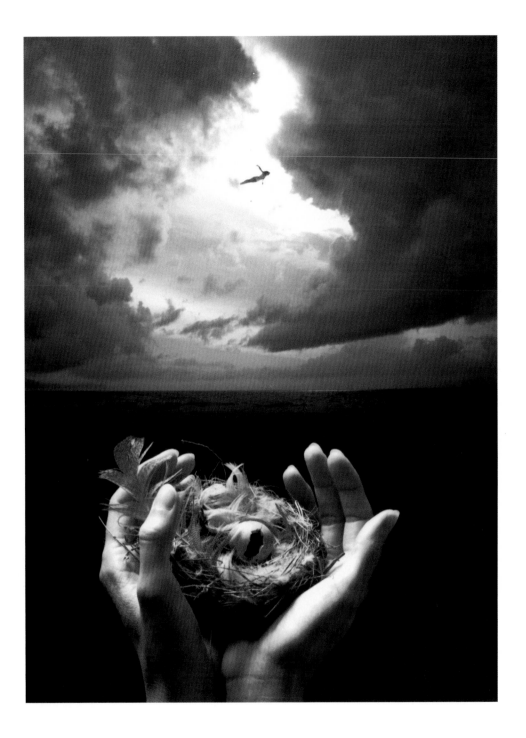

Untitled

Jerry Uelsmann
20" x 16" (51 x 40 cm)
Gelatin Silver Combination Print 1998

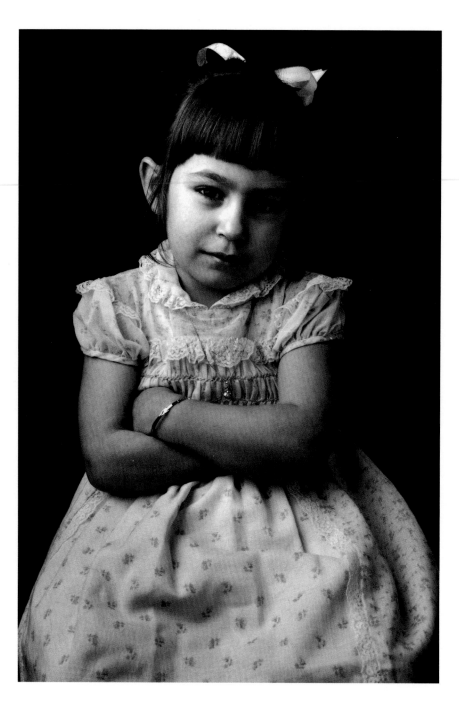

Four Years Old Living with Aids, Now Deceased

Harvey Stein
14" x 11" (36 x 28 cm)
Selenium-toned Gelatin Silver Print 1992

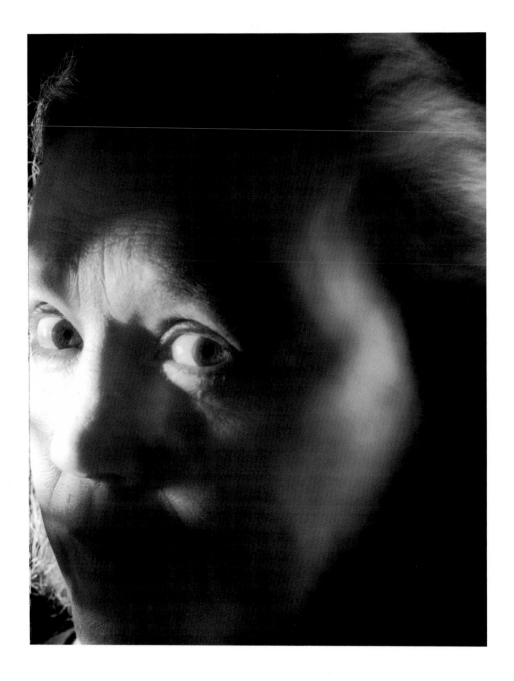

GG

Judith Harold-Steinhauser
14" x 11" (36 x 28 cm)
Gelatin Silver Print 1997

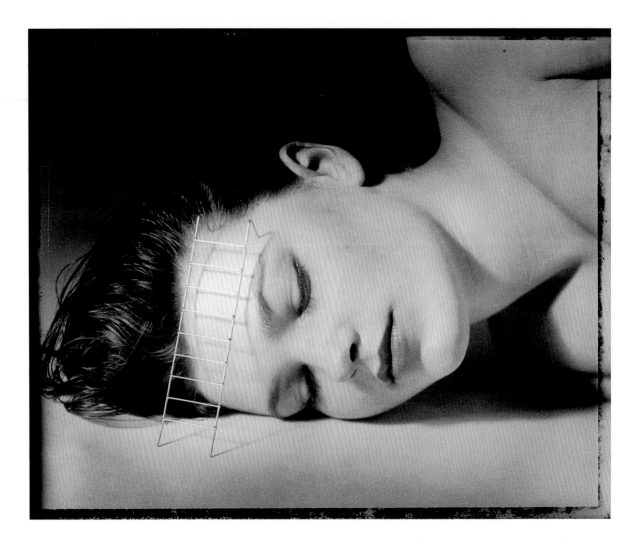

Ladder

Pavel Baňka
16" x 20" (41 x 51 cm)
Toned Gelatin Silver Print 1986

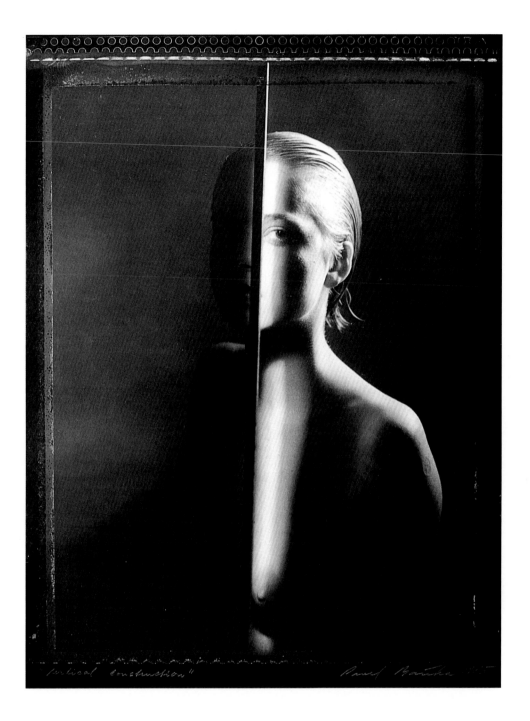

Vertical Construction

Pavel Baňka
20" x 16" (51 x 41 cm)
Toned Gelatin Silver Print 1985

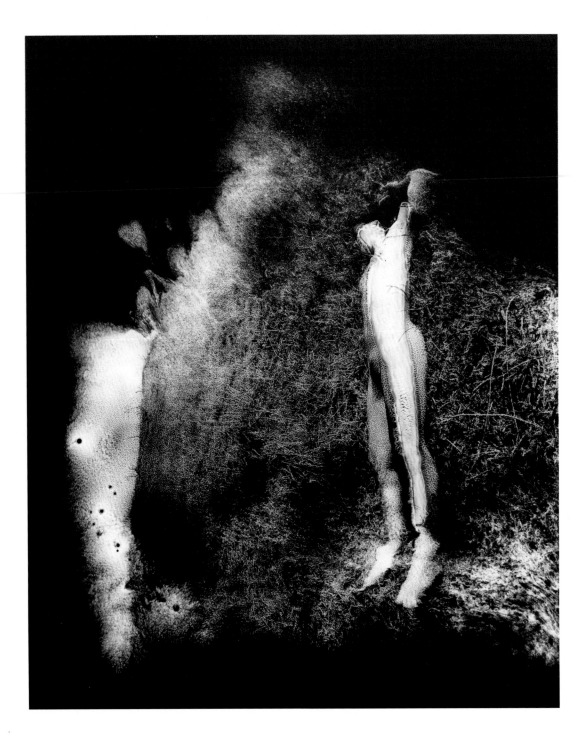

Iowa Image #1

Michael Teres
14" x 11" (36 x 28 cm)
Gelatin Silver Print 1996

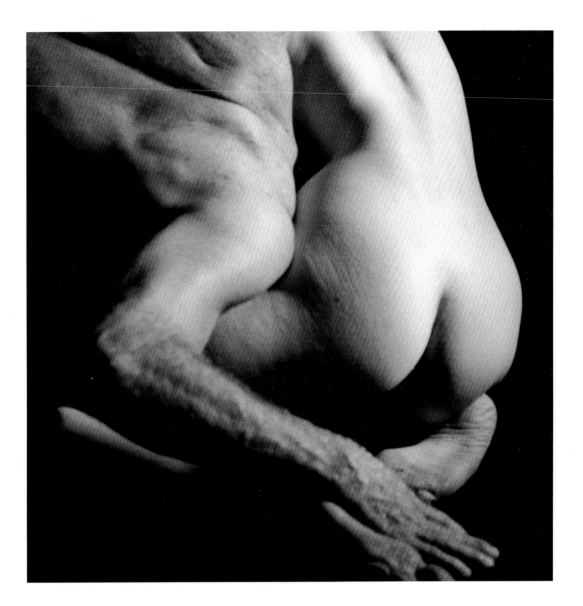

Untitled

Anita Ricardo
5" x 5" (13 x 13 cm)
Toned Gelatin Silver Print 1998

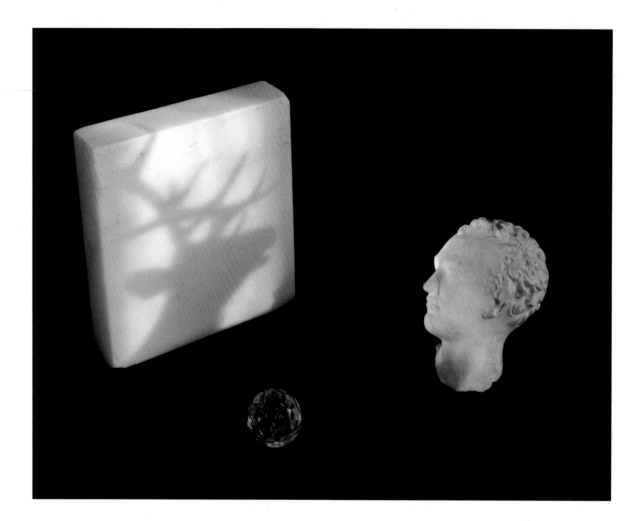

Heads

Olivia Parker
16" x 20" (41 x 51 cm)
Gelatin Silver Print 1991

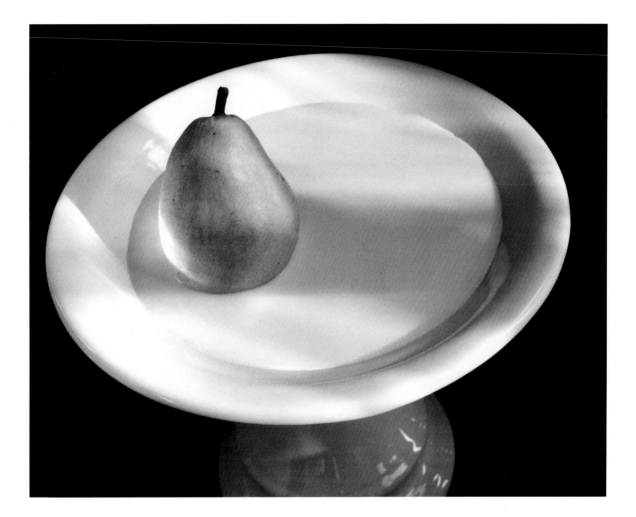

Form and Substance

Olivia Parker
16" x 20" (41 x 51 cm)
Gelatin Silver Print 1993

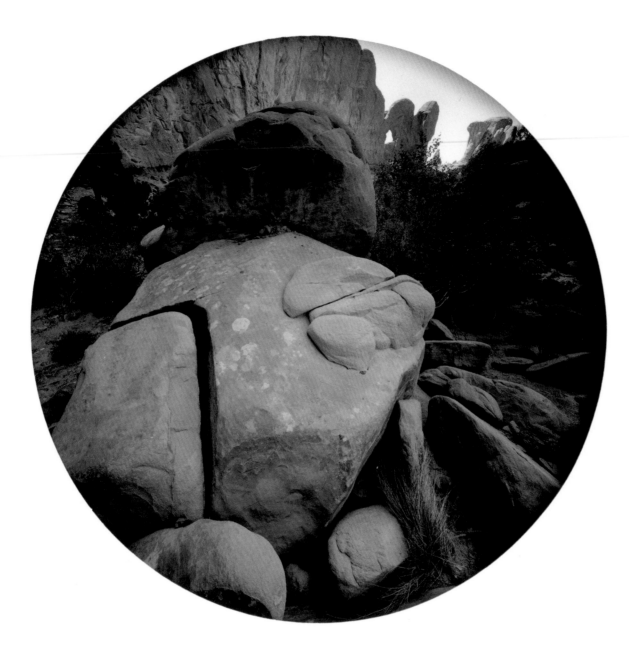

Untitled

Sam Wang
20" x 20" (51 x 51 cm)
Gelatin Silver Print 1994

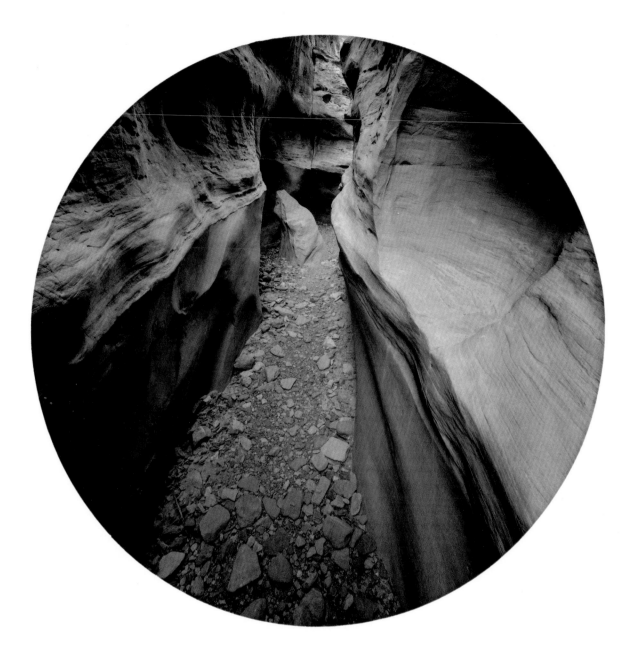

Canyon Passage

Sam Wang
20" x 20" (51 x 51 cm)
Gelatin Silver Print 1994

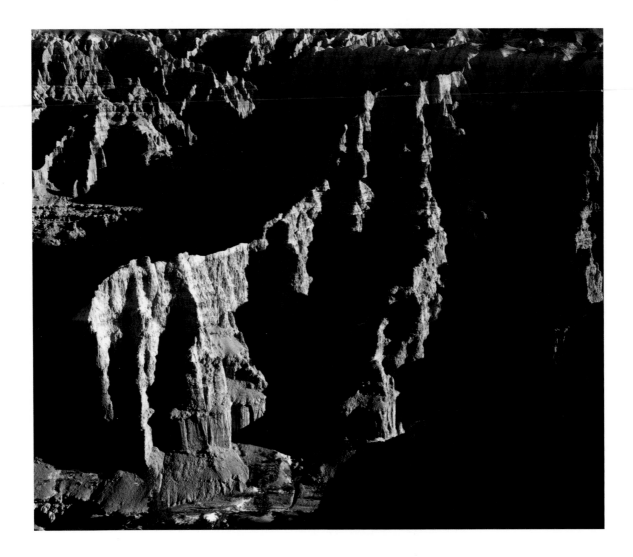

School of Mines Canyon, Badlands National Park

Fredrik Marsh
13 ½" x 16 ½" (34 x 42 cm)
Selenium-toned Gelatin Silver Contact Print 1987

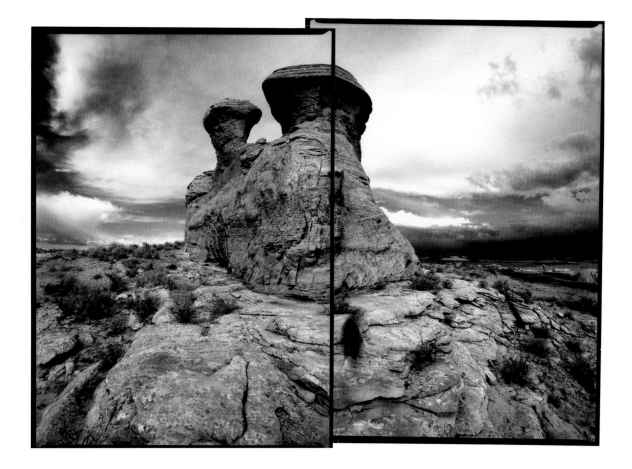

Extended Landscape

Roger Freeman
24" x 30" (61 x 76 cm)
Gelatin Silver Print 1993

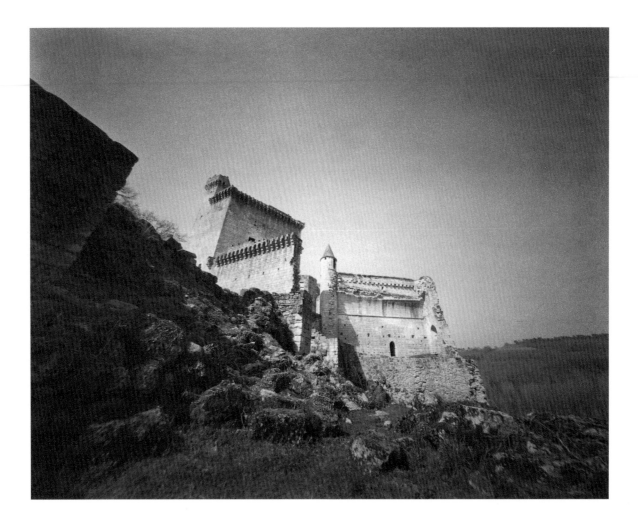

Chateau de Commarque, France 1998

Jojo Ans
8" x 10" (20 x 25 cm)
Platinum/Palladium Print 1998

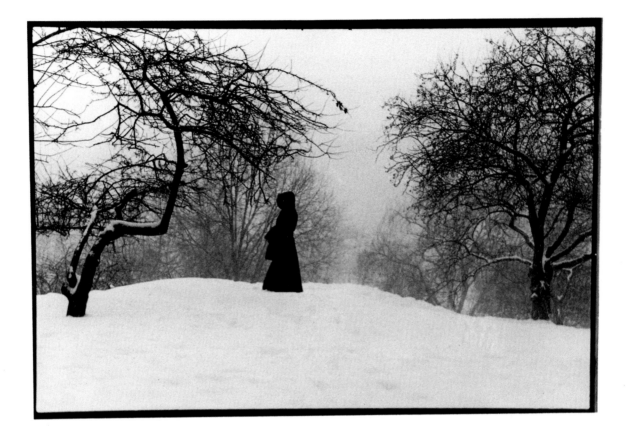

Hooded Figure, Riverside Park, New York City

Leonard Speier
14" x 17" (36 x 43 cm)
Gelatin Silver Print 1984

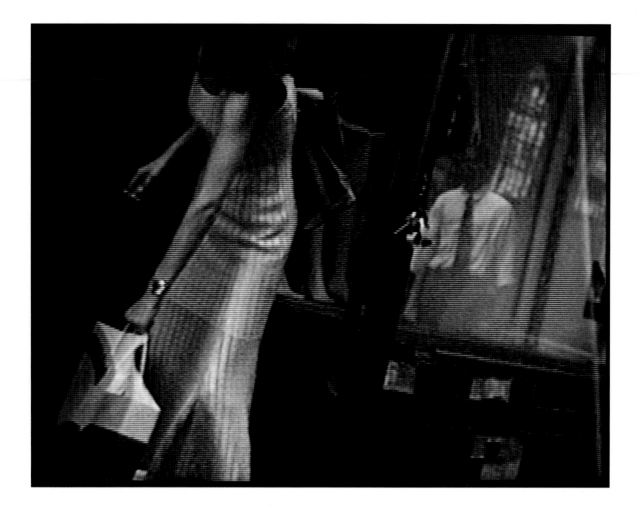

Woman With Shopping Bag, New York City, 1994

Don Lokuta
13 ½" x 18" (34 x 46 cm)
Gelatin Silver Print 1994

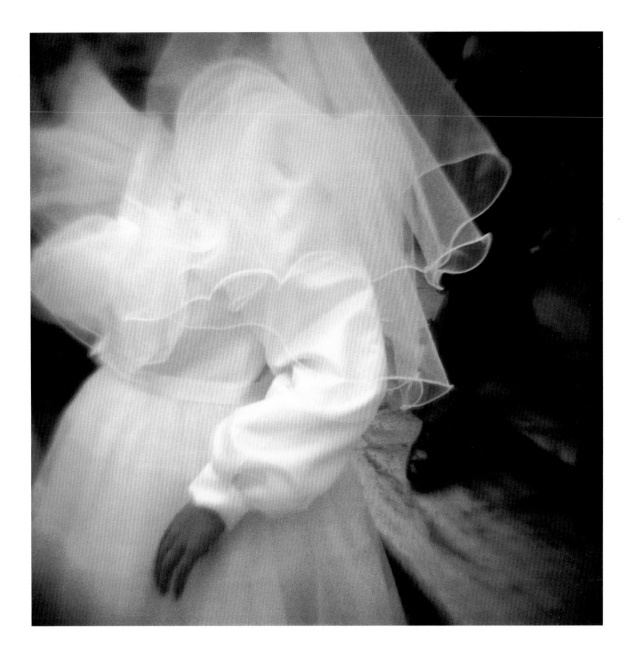

Vatican/Child Bride 1987

Christopher James
12 ½" x 12 ½" (32 x 32 cm)
Selenium and Gold-toned Gelatin Silver Print 1987

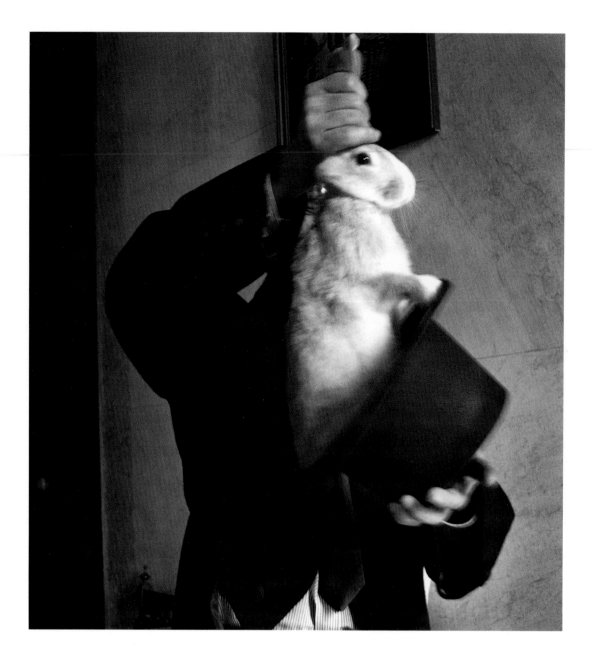

Uncle Herminio

Debbie Fleming Caffery
24" x 20" (61 x 51 cm)
Gelatin Silver Print 1992

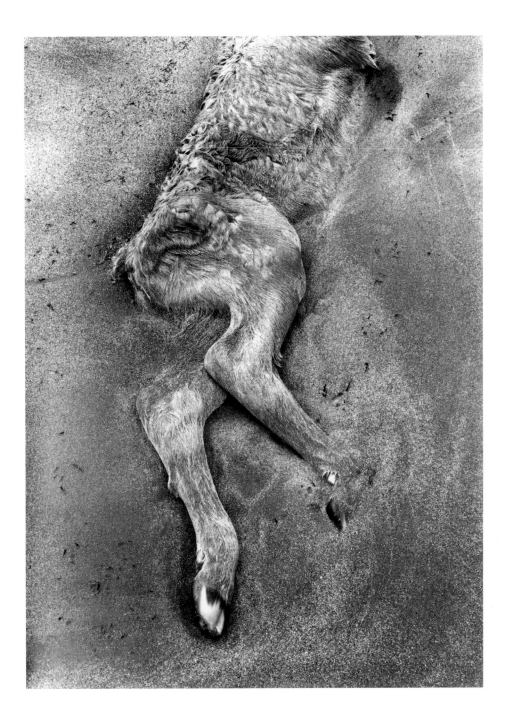

Pan Ascending, Kerry, Ireland 1993

Paul Caponigro
18 ¾" x 14" (47.5 x 36 cm)
Gelatin Silver Print 1993

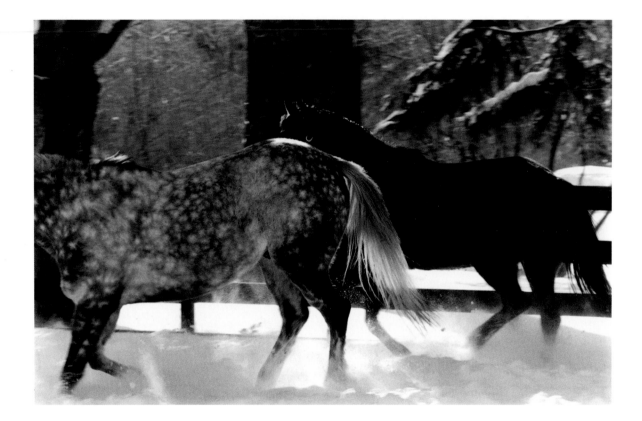

Winter Light

Ann Morse
8" x 10" (20 x 25 cm)
Gelatin Silver Print 1989

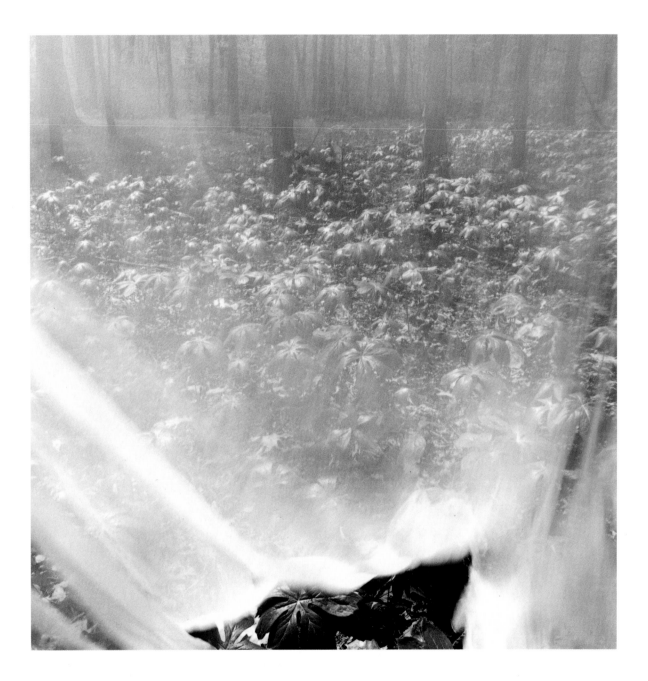

Untitled

Susan Moldenhauer
9" x 9" (23 x 23 cm)
Toned Gelatin Silver Print 1986

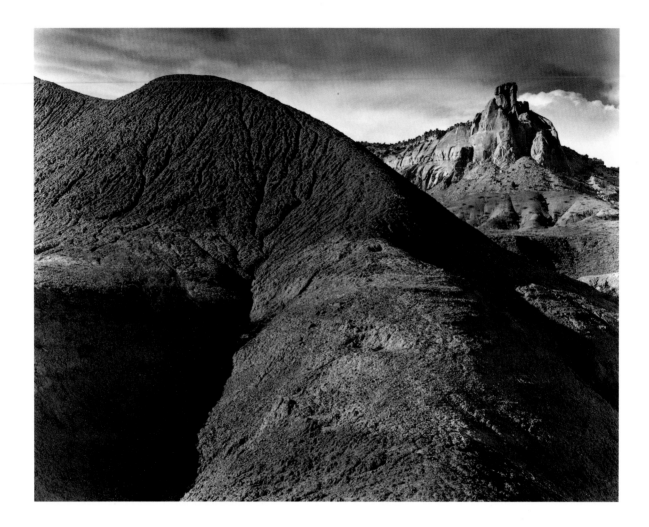

Badland Formations and Chimney Rock, Ghost Ranch, New Mexico, 1991

Janet Russek
11" x 14" (28 x 36 cm)
Gelatin Silver Print 1991

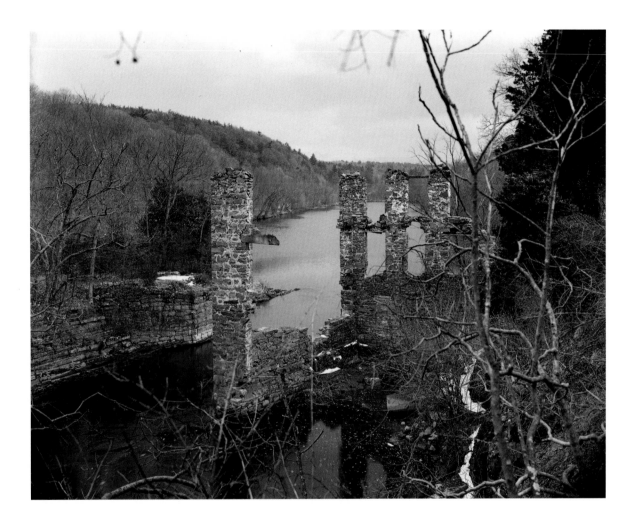

Cotton Mill on the Walkill River, Rifton, NY 1997

Forrest Holzapfel
8" x 10" (20 x 25 cm)
Toned Gelatin Silver Contact Print 1997

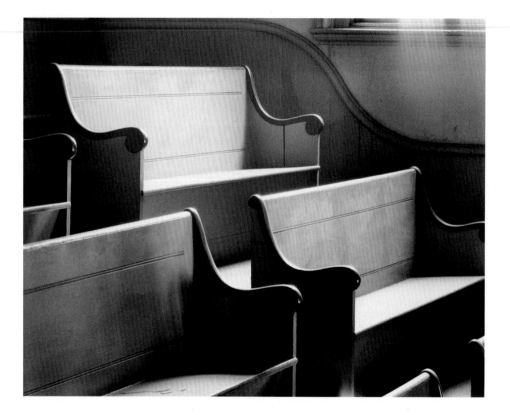

Balcony Benches, Old Boston City Hall, 1969

William Clift
1969

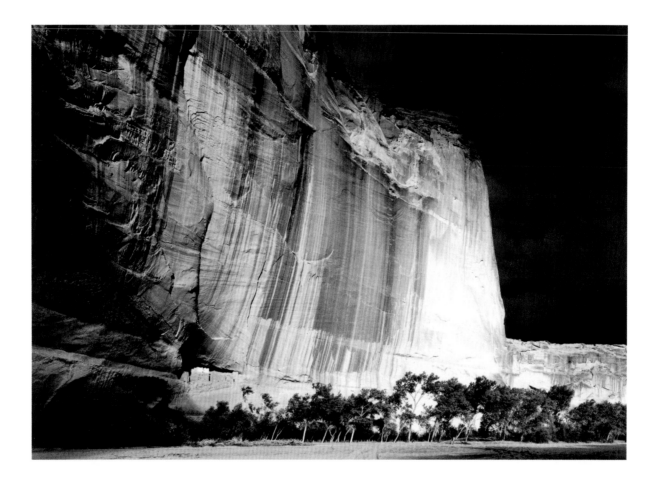

White House Ruin, Canyon de Chelly, Arizona

William Clift
1975

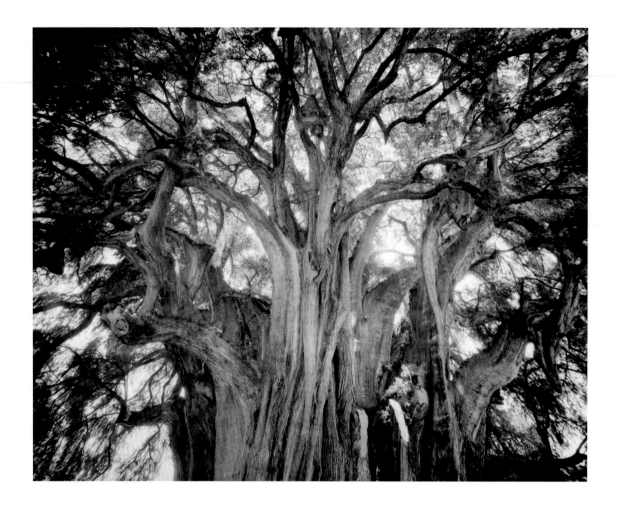

Largest Tree in Western Hemisphere, Tule, Oaxaca, Mexico

William Jaeger
11" x 14" (28 x 36 cm)
Sulfide/Selenium-toned Gelatin Silver Print 1997

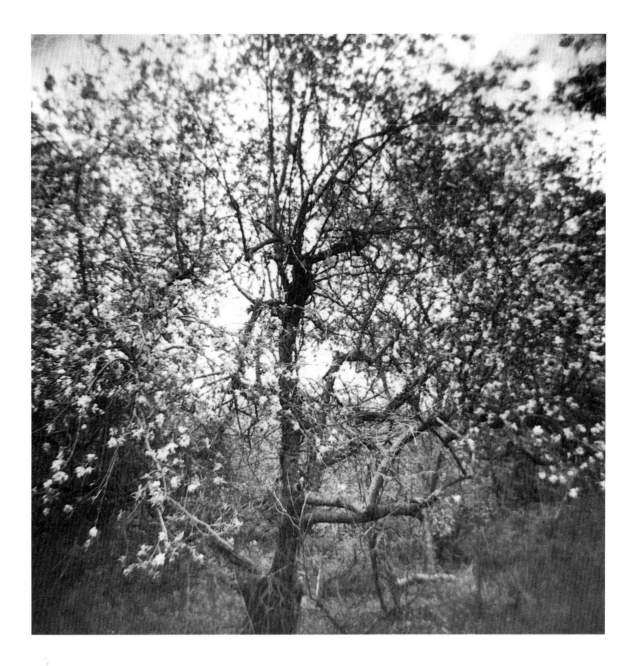

Apple Tree

Patricia Germani
9" x 9" (23 x 23 cm)
Platinum Print 1999

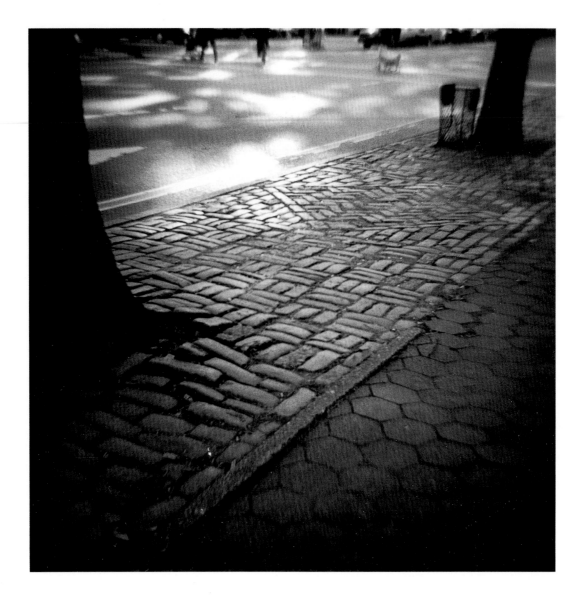

New York City, 1995

Jonathan Bailey
6" x 6" (15 x 15 cm)
Split-toned Gelatin Silver Print 1995

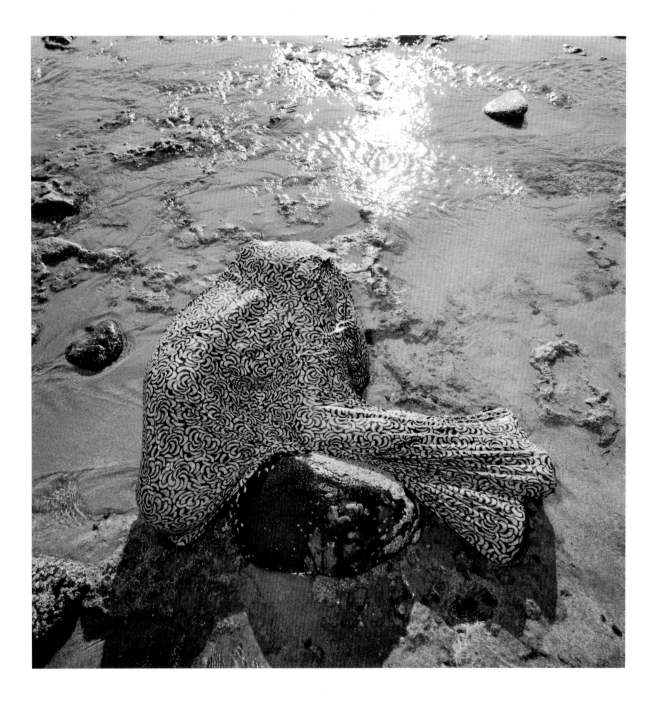

Shrouded: Embryo

Ann Simmons-Myers
19" x 19" (48 x 48 cm)
Selenium-toned Gelatin Silver Print 1996

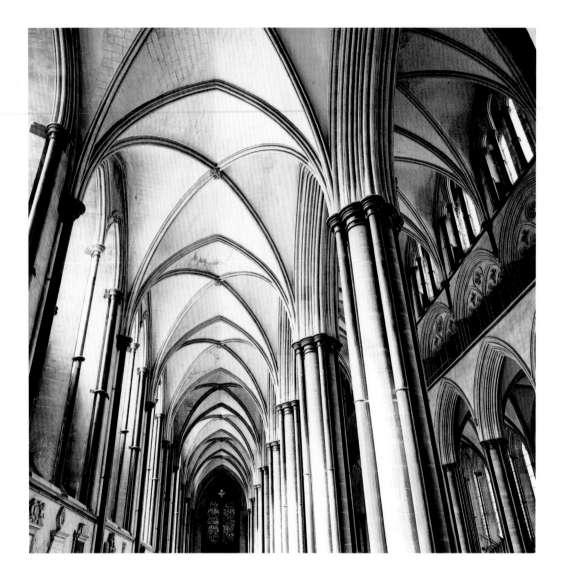

Salisbury Cathedral, England

Helene Penn
6" x 6" (15 x 15 cm)
Dye Sublimation Print 1997

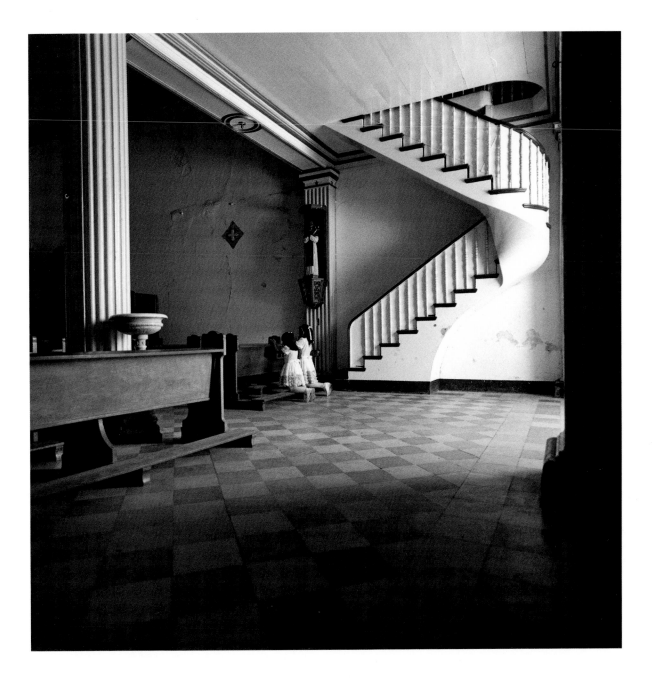

Two Girls Kneeling, Barvas, Costa Rica

Mario Algaze
15" x 15" (38 x 38 cm)
Gelatin Silver Print 1987
Throckmorton Fine Arts

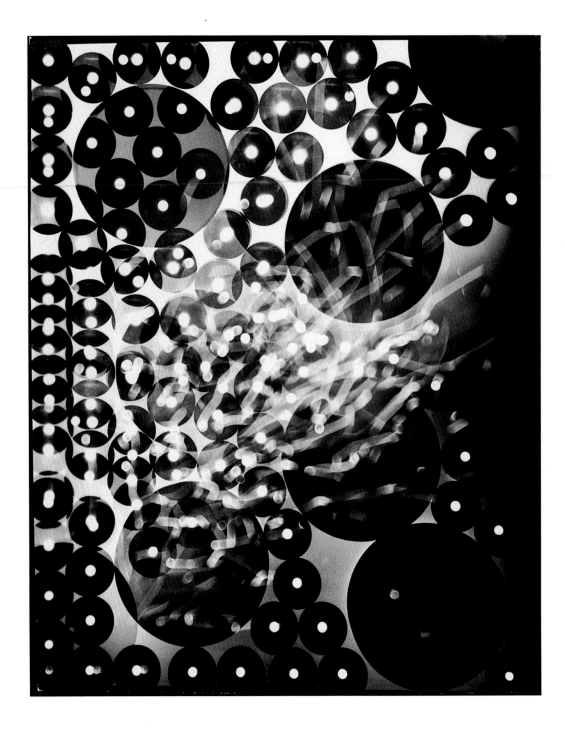

Photogenic Drawing

Ellen Carey
20" x 16" (51 x 41 cm)
Gold-toned Gelatin Silver Print (paper negative from photogram) 1999

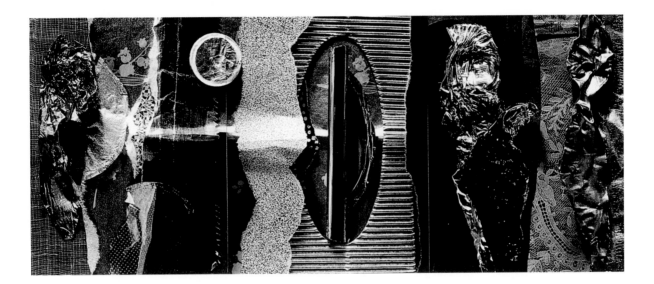

Untitled Triptych 288-285-282, 1997

Carl Chiarenza
19" x 45" (48 x 114 cm)
Selenium-toned Gelatin Silver Print 1997

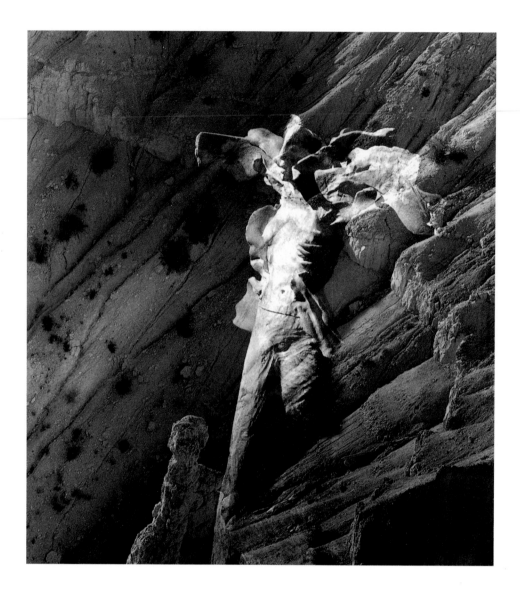

Messenger

Renata Rainer
8 ¼" x 7 ½" (20.5 x 19 cm)
Photomontage/Silver Print 1995

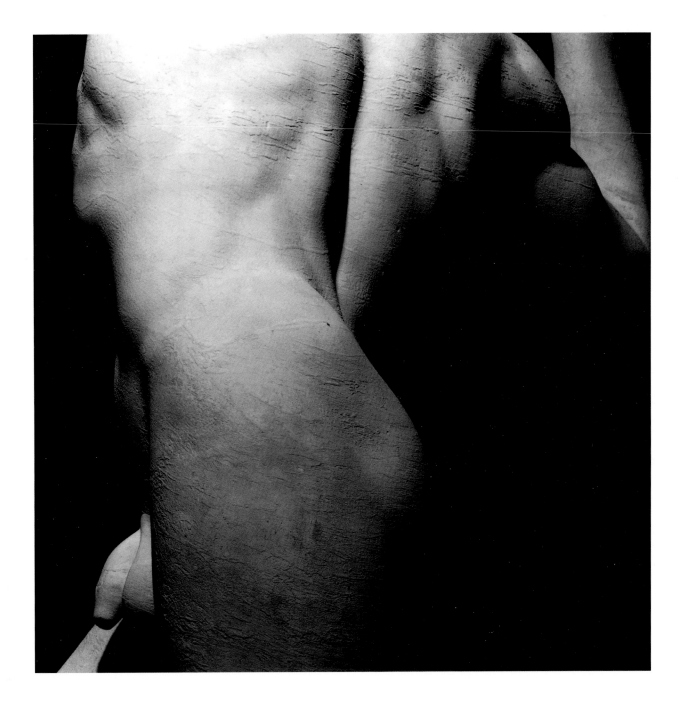

Marble Stadium Athlete, Rome, 1997

Roberto Schezen
30" x 40" (76 x 102 cm)
Gelatin Silver Print 1997
Edwynn Houk Gallery

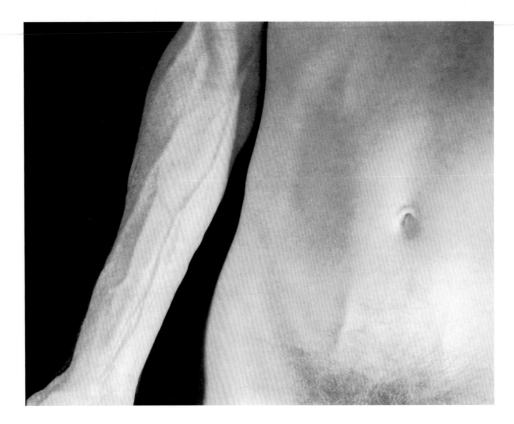

Untitled

Tanya Marcuse
4" x 5" (10 x 13 cm)
Platinum/Palladium Print 1992

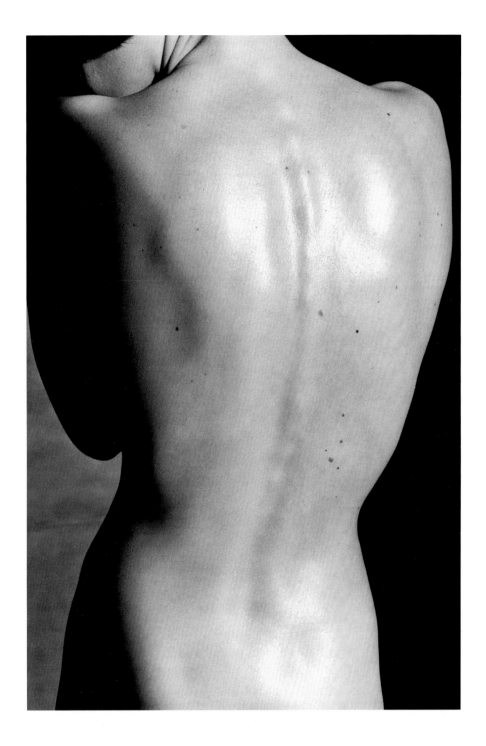

Arched Back

Joris Van Daele
10" x 8" (25 x 20 cm)
Gelatin Silver Print 1993

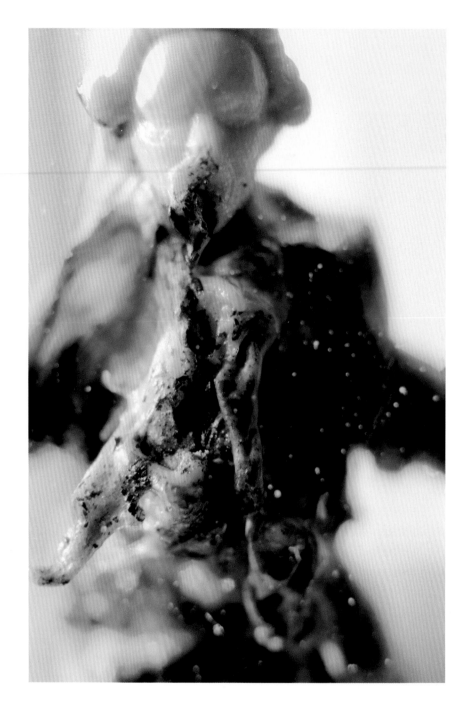

Los Desastres de la Guerra

Andreas Horvath
6' x 4' (1.8 x 1.2 meters)
Gelatin Silver Print 1990

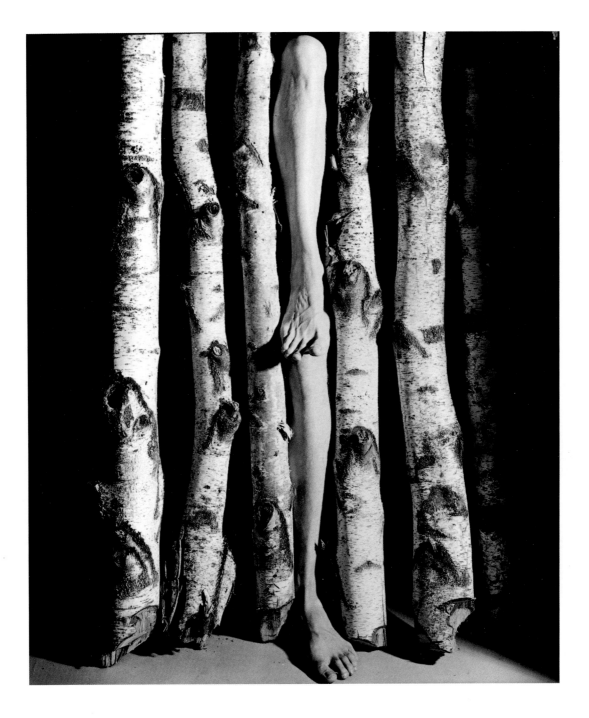

Mattomies, No. 14, 1983

Arno Rafael Minkkinen
24" x 20" (61 x 51 cm)
Black-and-White Polaroid 1983
Courtesy Photo & Co., Torino; Barry Friedman Ltd.,
New York; Nathalie C. Emprin
Paris

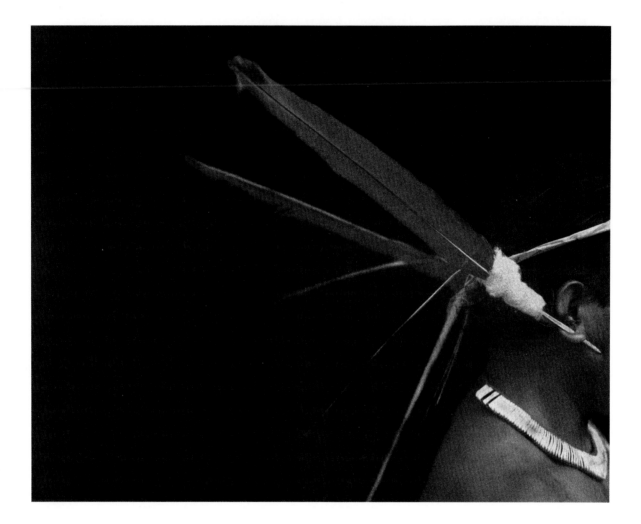

The Feather Silence

Per Fronth
22" x 30" (56 x 76 cm)
Photoengraving 1998
Throckmorton Fine Arts

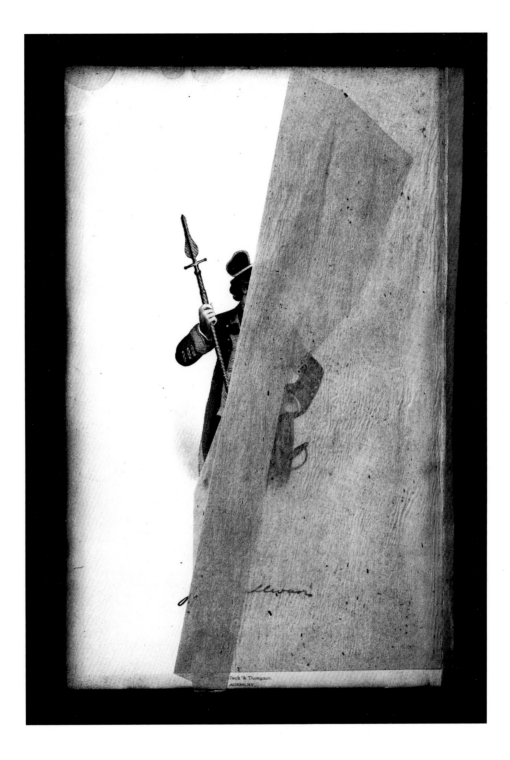

Sullivan Flyleaf

Earl McAlan Greene, Jr.
9 ½" x 6 ⅜" (24 x 16 cm)
Toned Gelatin Silver Print 1996

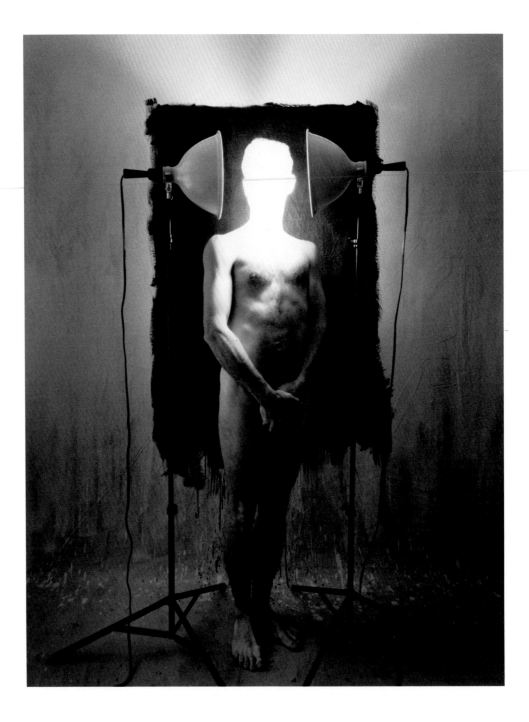

Untitled

Oren Slor
14" x 11" (36 x 28 cm)
Gelatin Silver Print 1987

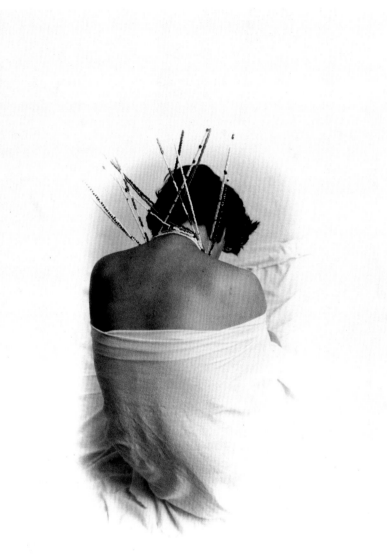

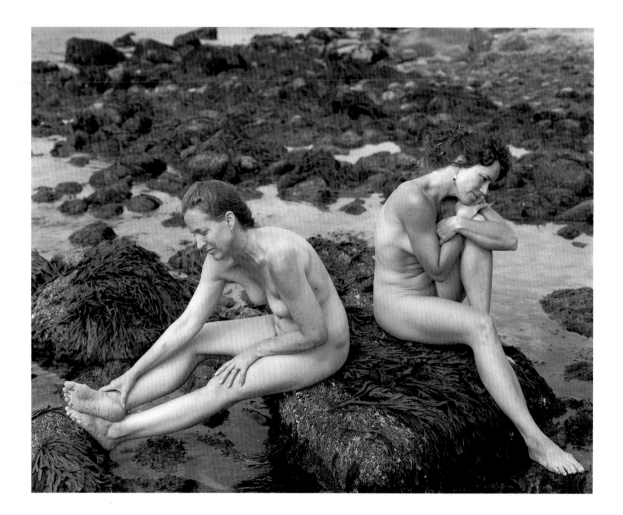

Beach People, Gay Head/Aquinnah, MA Betsy and Jan

Stephen DiRado
7 ½" x 9 ½" (19 x 24 cm)
Toned Gelatin Silver Contact Print 1997

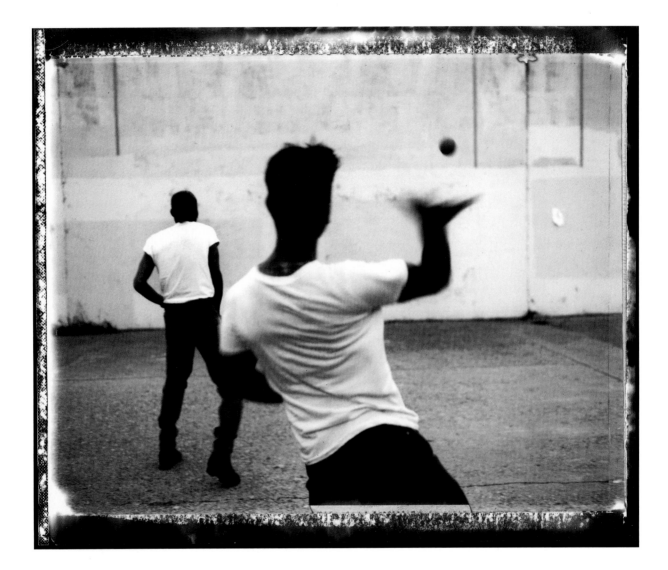

Handball 1, McCarren Park, Williamsburg, Brooklyn

Vincent Cianni
16" x 20" (41 x 51 cm)
Gelatin Silver Print 1994

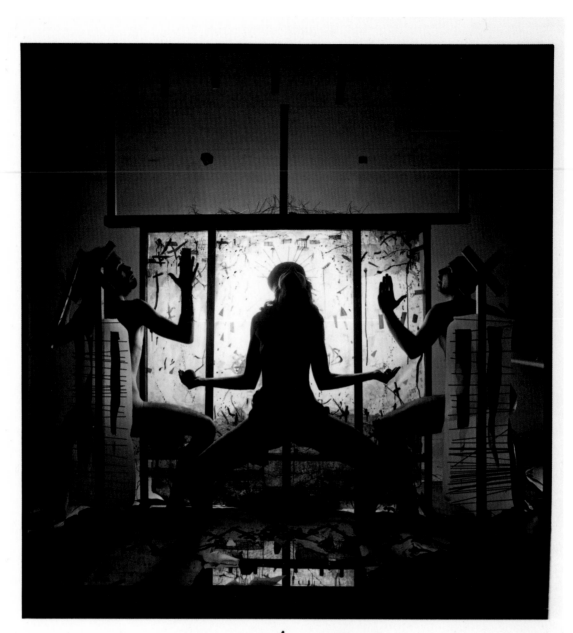

MYSTICKÝ PRÍBEH

The Mystic Story

Rudo Prekop
23 ½" x 19 ½" (60 cm x 50 cm)
Toned Gelatin Silver Print 1989

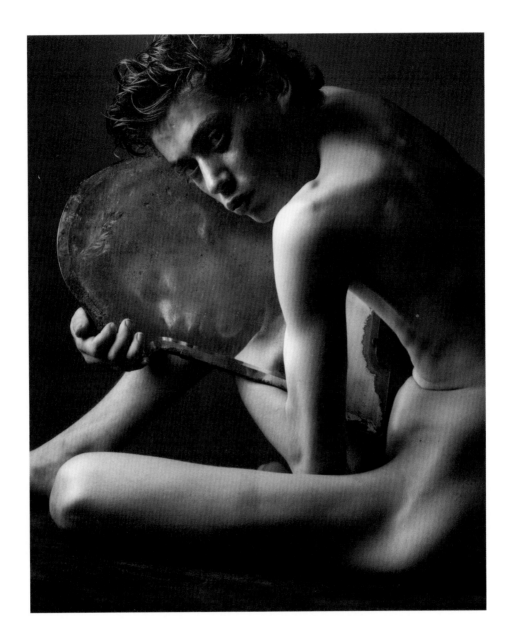

Narcissus

Ivan Pinkava
23 ½" x 19 ½" (60 x 50 cm)
Gelatin Silver Print 1977

From the series **Surface of the City**

Masahiro Oku
9" x 11" (23 x 28 cm)
Gelatin Silver Print 1991

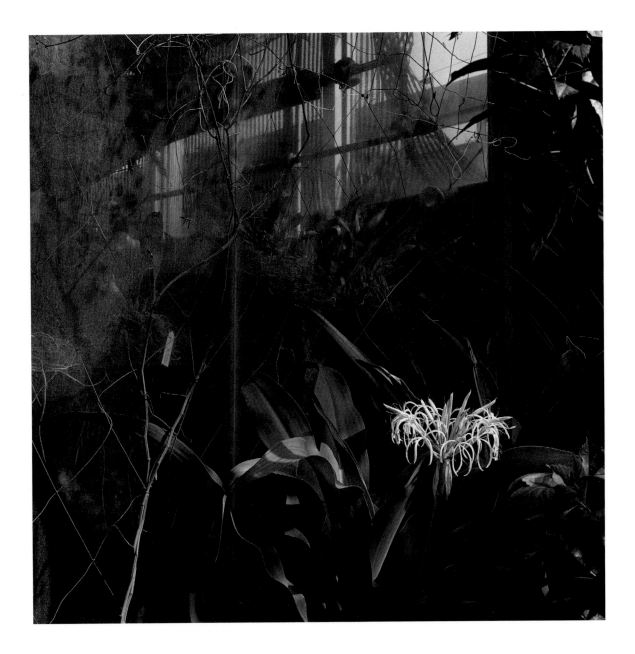

From the series **Glasshouse**

Masahiro Oku
9 ½" x 9 ½" (24 x 24 cm)
Gelatin Silver Print 1994

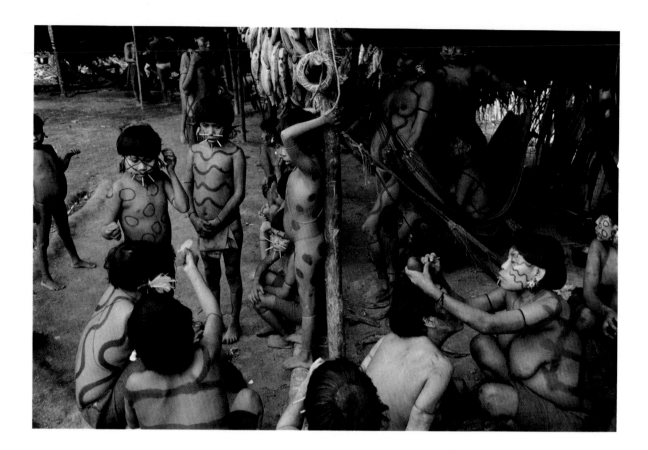

Yanomano Series XXIII

Valdir Cruz
12" x 18" (30 x 46 cm)
Gelatin Silver Print 1997
Throckmorton Fine Arts

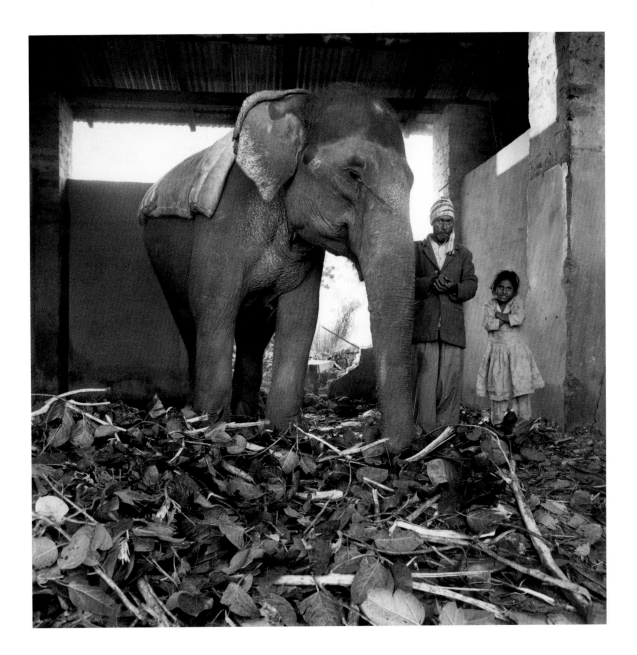

Hati Wallah, Corbett Park, India

Christopher Allibone
13 ½" x 13 ½" (34 x 34 cm)
Gelatin Silver Print 1989

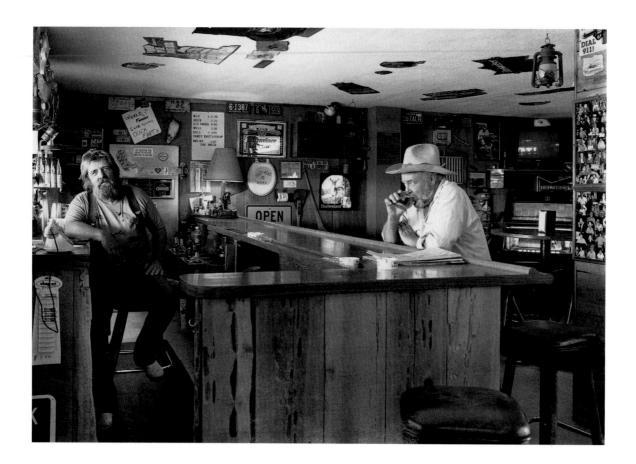

Cold Springs Tavern (1994)

Steve Anchell
11" x 14" (28 x 36 cm)
Gelatin Silver Print 1994

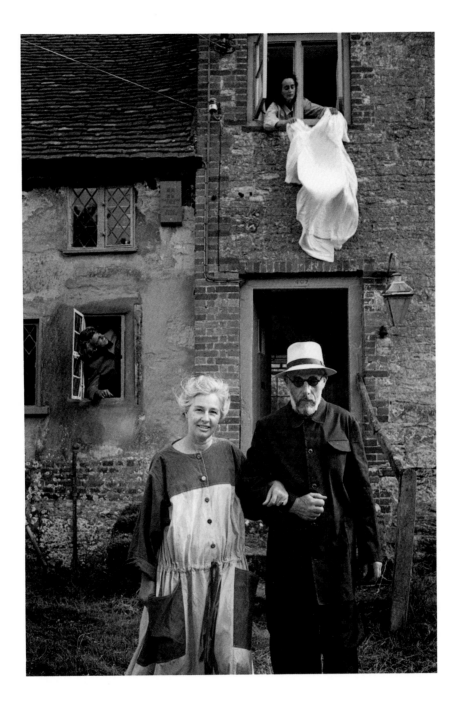

G and V at Home

Emily Andersen
10" x 8" (25 x 20 cm)
Gelatin Silver Print 1989

Statue of Wagner in the Tierleartew, Berlin, 1987

Richard Edelman
24" x 20" (61 x 51 cm)
C Print 1987

Oranienburger Synagogue Under Restoration, Berlin, 1990

Richard Edelman
24" x 20" (61 x 51 cm)
C Print 1990

Drechos

Albert Chong
30" x 40" (76 x 102 cm)
Gelatin Silver Print 1991
Throckmorton Fine Arts

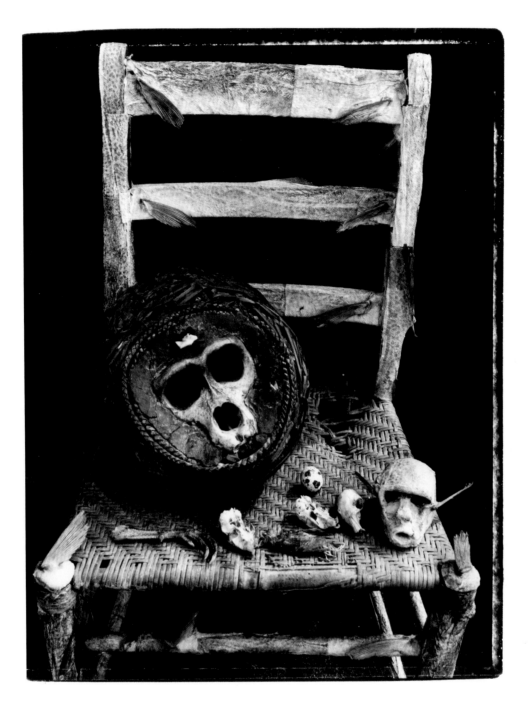

Throne for the Ancestors

Albert Chong
19" x 15" (48 x 38 cm)
Gelatin Silver Print 1987
Throckmorton Fine Arts

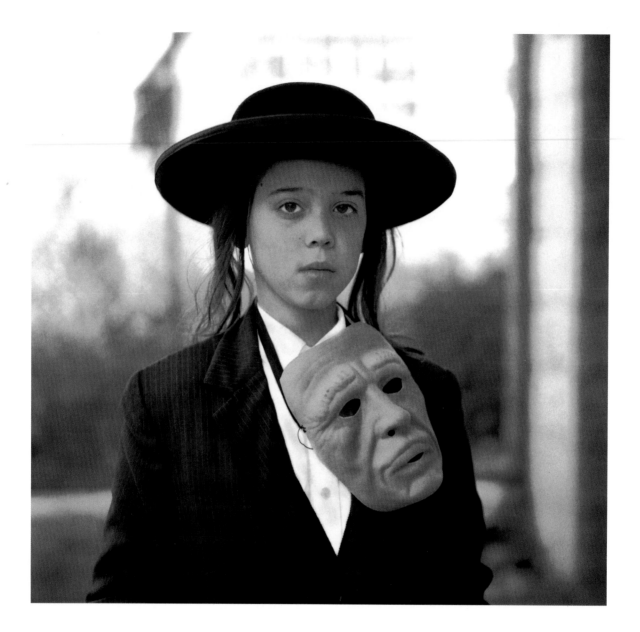

Jerusalem, Israel 1995 #112

Bruce Bennett
16" x 16" (41 x 41 cm)
Iris Print 1995

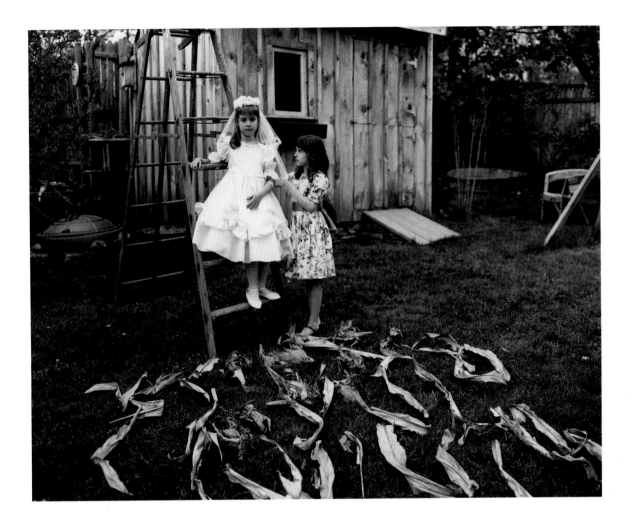

Untitled

Lawrence Lewis
8" x 10" (20 x 25 cm)
Gelatin Silver Contact Print 1994

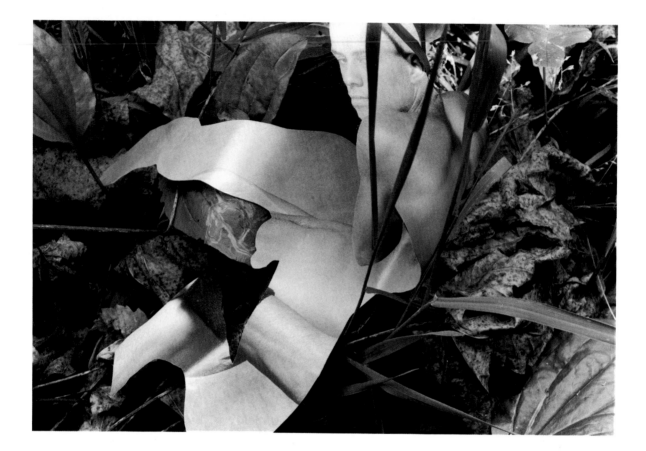

Untitled (number 10)

Joy Taylor
9" x 13" (23 x 33 cm)
Gelatin Silver Print 1997

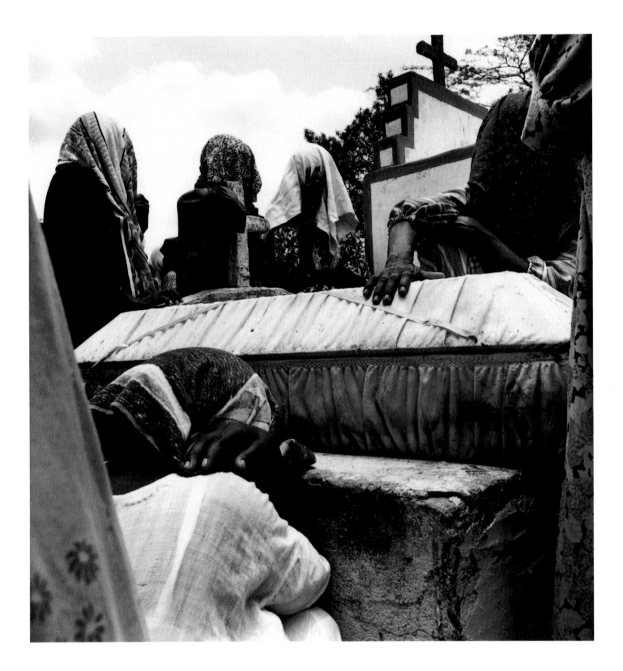

Women Mourning in the Guajira, Colombia

Bastienne Schmidt
15" x 15" (38 x 38 cm)
Gelatin Silver Print 1991
Throckmorton Fine Arts

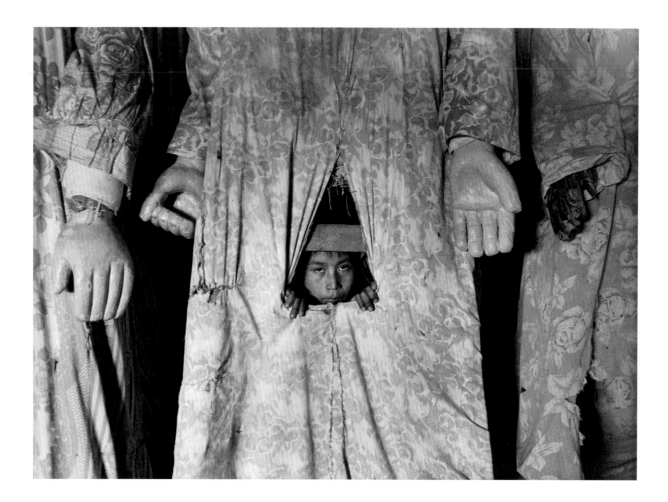

She Giant, Sumpango, Guatemala

Flor Garduño
11" x 14" (28 x 36 cm)
Gelatin Silver Print 1989
Throckmorton Fine Arts

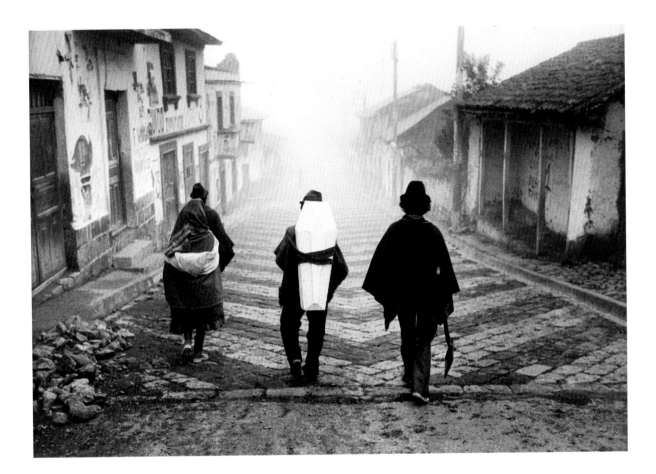

Camino al camposanto

Flor Garduño
11" x 14" (28 x 36 cm)
Gelatin Silver Print 1988
Throckmorton Fine Arts

Mario Algaze
c/o Throckmorton Fine Art
153 East 61st Street
New York, NY 10021

Mario Algaze was born in Havana, Cuba, in 1947 and migrated from Cuba to Miami in 1960. In 1971, at the age of twenty-four, Algaze began his photographic career. Photographing Latin America offered a creative way to deal with his exile and Latin American roots. In 1979, Algaze became owner and director of Gallery Exposures in Coral Gables. Since dedicating himself full time to being a photographer, Algaze's work has been exhibited in various museums throughout the United States, Latin America, and Europe. He is represented in New York by Throckmorton Fine Art.

Christopher Allibone
1537 Old Ford Road
New Paltz, NY 12561

Christopher Allibone began his career in photography at the State University of New York at New Paltz. After graduating in 1989, he moved to eastern Europe to photograph the war in Croatia. Later, he traveled to northern Iraq and other Kurdish regions to document the Kurdish refugees returning home after the Gulf War. His work has appeared in the *New York Times,* the *Utne Reader,* and the *Encyclopedia Britannica.* He teaches photography at SUNY New Paltz.

Juan Carlos Alom
c/o Throckmorton Fine Art
153 East 61st Street
New York, NY 10021

Juan Carlos Alom was born in Cuba in 1964 and studied photography at the Semiotica del entorno Cubano, Institute of International Journalism, in Havana. In 1985, Alom started working as a photojournalist for the Cuban press and in 1989 started experimenting with the photographic medium. This resulted in photographs that have been visibly manipulated by his hand and are recognizable for their dark backgrounds that act as metaphors for the mythical themes of his images. He is represented in New York by Throckmorton Fine Art.

Steve Anchell
234 Sweetgrass Overlook
PO Box 277
Cretone, CO 81131

Steve Anchell has been a contributing editor to numerous national magazines and has written columns, feature articles, and interviews for *View Camera, PIC, Shutterbug,* and *Rangefinder* magazines. His first two books, *The Darkroom Cookbook* and *The Variable Contrast Printing Manual,* both are international photography bestsellers. His third book, *The Film Developing Cookbook,* was released in December 1998. Anchell has conducted numerous prestigious workshops and guest lectures since 1979 and currently is program director for the Photographers' Formulary Workshops in Montana.

Emily Andersen
42 Chepstow Place
London, UK W2 4TA

Emily Andersen is a photography graduate from the Royal College of Art. She lives and works in London. She has published and exhibited extensively throughout the United Kingdom, Europe, and the United States. Her publications include *Our Mothers* (Stewart Tabon and Chang) and *Disrupted Borders* (Rivers Oram Press, 1993). She won the John Kobal Award for portraiture in 1998. Her work appears in the National Portrait Gallery Connection (London) and is represented by the Francis Graham-Dixon Gallery.

JoJo Ans
11A Waterside Lane
New Paltz, NY 12561

JoJo Ans studied photography at SUNY New Paltz and interned at the Center for Photography at Woodstock. Her work has been represented by The Platinum Gallery in Santa Fe and exhibited in numerous group shows. She has received two MacDowell fellowships (1995, 1997). Ans has photographed and traveled extensively in southern France. She now lives and photographs in the Hudson Valley and manages the Woodstock Photography Workshops.

Jonathan Bailey
HC 61 Box 346
St. George, ME 04857

Jonathan Bailey began his fascination with the "Diana" camera (a $2 plastic toy) in 1979. His exotic split-toning techniques support the real yet dramatically transformed imagery he finds in Mexico, coastal Maine, Paris, and other favorite haunts. His work with this and other formats is exhibited internationally and is featured in numerous collections, including the Bibliothèque Nationale, Royal Photographic Society, and Southeast Museum of Photography.

Pavel Baňka
Bernice 8
103 00 Praha 10
Chech Republic

Originally an electrical engineer, Baňka became a cofounder of the Action-Group of Free Photography (1991). He has been the head of a photographic studio at the Institute of Art Culture of Jan Evangelista Purkyě University in Ústi nad Labem and has had solo shows at many galleries throughout the world. His photographs are in the collections of numerous influential museums and galleries, including the San Francisco Museum of Modern Art and Maison Europeenne de La Photographie (Paris).

Craig Barber
427 Manhattan Avenue
Brooklyn, NY 11222

Craig J. Barber is a photographer who travels and works exclusively with the pinhole format and focuses on the inhabited landscape. Exhibited throughout the United States, Europe, Mexico, and New Zealand, his work is represented in several public and private collections that include the Brooklyn Museum of Art, the Houston Museum of Fine Arts, the Minneapolis Institute of Art, the Polaroid Corporation, and the New York Public Library.

Martin Benjamin
1076 Briarwood Blvd.
Schenectady, NY 12308

Martin Benjamin is a professor of photography at Union College, New York. His photographs appear in numerous collections, and his work has been exhibited in group and solo shows throughout the United States, Europe, and the People's Republic of China. Photographs from his Rock Shots® series have been published internationally. His work is represented by Great Modern Pictures Gallery of New York City, Black Star photo agency, The ImageWorks stock agency, and his own Rock Shots® archive and stock photography outlet.

Bruce Bennet
1624 Monroe Avenue
Rochester, NY 14618

Bruce Bennet received his B.F.A. from the Rochester Institute for Technology in 1987. Since 1983, he has worked as a photography instructor for the Norman Howard School, Rochester, New York. He searches in his photography for fundamental values that enable people to live with harmony—regardless of their economic status—in or adjacent to modern complex societies. His current work, *Today's Israelis—A Country in Transition,* celebrates the resilience of the peoples of Israel.

Robert R. Bennett
575 12th Ave. #6
San Francisco, CA 94118

Bob Bennett grew up in Maine and attended St. Paul's School in Concord, New Hampshire. He has been an advertising art director (1976-1981) and was working as an architectural photographer (1981-1991) when he opened the Pandora's box of photomontage in the early 1980s. Since then, his work has appeared in numerous national publications, both on assignment and as stock, and in galleries and competitive exhibits on both coasts. He currently divides his time between Web graphics development and photomontage printing.

Martha Maria Perez Bravo
c/o Throckmorton Fine Art
153 East 61st Street
New York, NY 10021

Martha Maria Perez Bravo was born in Havana, Cuba, in 1959 and was educated at the San Alejandro Academy of Art and the Superior

Institute of Art in Havana, finishing her studies in 1984. After several years of formal training, Perez Bravo began using photography as a means to produce personal and often intimate images that illustrate rituals and mythological beliefs. Her imagery revolves around Cuba's syncretic culture, the Cuban exile, and rituals that are rooted in the Afro-Cuban religion. She is represented in New York by Throckmorton Fine Art.

Drex Brooks
1670 Binford Street
Ogden, UT 84401

Drex Brooks received his M.F.A. from the Rhode Island School of Design and now is professor of art at Weber State University, Ogden, Utah. He received Visual Artist Fellowships from the National Endowment for the Arts in 1988 and 1992. The numerous collections exhibiting Brook's work include the National Museum of American Art, the Smithsonian Institution (Washington, DC), the Bibliothèque Nationale (Paris), and the Polaroid Corporation International Collection (Offenbach, Germany).

Debbie Fleming Caffery
105 Washington Street
Breaux Bridge, LA 70517

Debbie Fleming Caffery's work has been shown in galleries and museums in the United States and abroad, including solo shows at the Cleveland Museum of Art, Howard Greenberg Gallery (New York), Photo Gallery International (Japan), and the Museum of Contemporary Photography (Chicago). Caffery's work is also represented in numerous major collections that include the Museum of Modern Art (New York), the Metropolitan Museum of Art (New York), the George Eastman House (Rochester), the Smithsonian Institute (Washington), and the Bibliothèque Nationale (Paris).

Paul Caponigro
10 Summer Street
PO Box 116
Rockport, ME 04856

With his first solo exhibition, at the George Eastman House in 1958, Paul Caponigro established himself as one of America's premier photographers. Through extensive exhibitions and workshops throughout the United States and abroad, Caponigro's images are in the permanent collections of numerous museums and private collections. Published extensively and the subject of several monographs, his photographs have been reproduced and discussed in numerous national and international journals, books, and magazines.

Ellen Carey
140 Huyshope Avenue
Hartford, CT 06106

Ellen Carey currently is an associate professor of photography at the Hartford Art School. Carey's work has been exhibited in numerous solo shows and in more than 150 group shows. Her many grants include ones from the Connecticut Commission for the Arts (1998) and the NEA (1984). Widely published and reviewed, her work also is represented extensively in public and private collections, including the Baltimore Museum of Art, the Brooklyn Museum of Art, the Fogg Art Museum (Harvard University), the George Eastman House (Rochester), and the Metropolitan Museum of Art (NYC).

Carl Chiarenza
5 Edgemore Drive
Rochester, NY 14618

Since 1958, Carl Chiarenza's work has appeared in sixty-five solo and 190 group exhibitions and has entered forty collections. His images also have been represented in 160 publications, most recently in *Keith Davis, An American Century of Photography* (1999). The author of *Aaron Siskind: Pleasures and Terrors,* and of many essays and reviews, Chiarenza is the subject of *Chiarenza: Landscapes of the Mind* (David R. Godine, Boston, 1988). The recipient of two NEA fellowships (1977, 1991), Chiarenza currently is Fanny Knapp Allen Professor Emeritus and Artist-in-Residence at the University of Rochester.

Albert Chong
c/o Throckmorton Fine Art
153 East 61st Street
New York, NY 10021

Born in Kingston, Jamaica, Albert Chong received his M.F.A. from the University of California, San Diego, in 1991. His photographs are included in public and private collections, and they have been widely exhibited nationally and internationally. Among other awards, he received a regional National Endowment for the Arts

Fellowship in Photography and a 1992 National Endowment for the Arts fellowship in photography. Friends of Photography published a book of his work titled *Ancestral Dialogues: The Photographs of Albert Chong.* He is represented in New York by Throckmorton Fine Art.

Vincent Cianni
136 Grand Street
Brooklyn, NY 11211

Vincent Cianni, born 1952, received his M.F.A. from SUNY New Paltz in 1986. A recipient of numerous awards, including a grant from the New York State Arts Council, Cianni's work has been exhibited in galleries around the country. His photographs have been published in *La Fotografia, Aperture,* and *Creative Camera.* They are represented in many public and private collections. Represented by the Photographers' Gallery, London, by Joseph Geraci, Amsterdam, and by Vance Martin, San Francisco, Cianni is currently an instructor in photography at Parson's School of Design.

William Clift
PO Box 6035
Sante Fe, NM 87502

William Clift moved to Sante Fe in 1971. He has received two National Endowment for the Arts Fellowships (1972, 1979) and two Guggenheim Fellowships (1974, 1980). He has published two books of his work, *Certain Places* (William Clift, 1987) and *A Hudson Lanscape* (William Clift, 1994).

Linda Connor
87 Rutherford
San Anselmo, CA 94960

Linda Connor is a professor at the San Francisco Art Institute where she has taught photography since 1969. Her photographs have been exhibited in over 300 galleries and museums in the United States and abroad, including the San Francisco Museum of Modern Art, MoPA, Museum of Modern Art (New York), and the Victoria and Albert Museum (London). Recognized with a Guggenheim Fellowship and two grants from the National Endowment for the Arts, Connor travels extensively throughout the world and has developed a deep interest in sacred sites.

Barbara Crane
1230 West Washington Street
Chicago, IL 60607

Barbara Crane has explored photography as a vehicle for creative expression for over fifty years. She retired from the School of the Art Institute of Chicago as professor emeritus in 1993. With work in many private, corporate, and museum collections, Crane's numerous awards include National Endowment for the Arts grants (1974, 1988) and a John Simon Guggenheim Memorial Fellowship in Photography (1979). Galleries throughout the United States and Europe represent her work.

Valdir Cruz
c/o Throckmorton Fine Art
153 East 61st Street
New York, NY 10021

Recipient of a 1996 Fellowship from the John Simon Guggenheim Foundation, Valdir Cruz has become a household name in his native Brazil. He is regarded as a concerned artist whose acceptance by native peoples shows his respect for his subjects is of utmost importance to him. For the past five years, Cruz's work has focused on some of the oldest peoples in the world—the indigenous groups of the Amazon rainforest. He is represented in New York by Throckmorton Fine Art.

Regina DeLuise
7700 Takoma Avenue
Takoma Park, MD 20912

Regina DeLuise is a Guggenheim Fellow whose work is represented in many collections, including the Museum of Modern Art and the Metropolitan Museum (New York), the Art Institute of Chicago, the Museum of Modern Art (San Francisco), and the Canadian Centre of Architecture (Montreal). She has exhibited at galleries from Tokyo to London and is represented by Bonni Benrubi Fine Arts in New York.

Stephen DiRado
52 Gage Street
Wincester, MA 01605

Stephen DiRado completed his B.F.A. at the Massachusetts College of Art in 1981. He currently teaches photography at Clark University's Visual and Performing Arts Department, Worcester, Massachusetts. DiRado is a nationally recognized photographer

with work in many public and private collections, including the Houston Museum of Fine Arts, the DeCordova Art Museum, and the Worcester Art Museum. His numerous awards include a National Endowment for the Arts fellowship (1991) and three Massachusetts Artist Foundation fellowships.

Richard Edelman
7 West 22nd Street, 10th floor
New York, NY 10010

Richard Edelman holds an M.F.A. degree from Pratt Institute and has been an architectural photographer and teacher for more than twenty years. His photographs appear in many public and private collections, including the Metropolitan Museum of Art (NYC), the Bibliothèque Nationale, and the Canadian Centre for Architecture. He has been the recipient of a CAPS award (1982) and has exhibited extensively. Currently, he is working on a book project tentatively titled, *Berlin Has Roses: An Urbanscape of Imaginings*.

David Emerick
45358 Joy Point Lane
California, MD 20619

David Emerick was born in upstate New York. He received a B.F.A. in photography from the University of Kentucky in 1982 and an M.F.A. in photography from the University of Nebraska. He has taught at the Corcoran School of Art; the Smithsonian Institute in Washington, DC; and Northern Virginia Community College and St. Mary's College of Maryland. Many public and private institutions and individuals have collected his work.

Will Faller
PO Box 300
Tillson, NY 12486

Will Faller has taught at the School of Visual Arts (NYC) and in workshops nationally. His books include *Violence, Dude Ranches of the American West* and *A Woman's Ire* (in progress). Faller exhibits nationally, and he appears in many private and public collections, including the Metropolitan Museum of Art (NYC), the Philadelphia Museum of Art, and the Houston Museum. Recent projects include powerful interpretive social essays on Haiti, India, and Texas' Rio Grande Valley. His environmental portraits are widely published. Editorial clients include *Life, Newsweek,* and *Money;* commercial clients include KEYCORP and IBM.

Sandi Fellman
Sandi Fellman/co Tanya Murray
Edwynn Houk Gallery
745 Fifth Avenue
New York, NY 10151

Sandi Fellman was born in Detroit, Michigan, in 1952 and received her M.F.A. in 1976 from the University of Wisconsin, Madison. Her work has been featured in numerous solo and group exhibitions in the United States, Europe, Japan, and Australia over the past fifteen years. She has also curated a large collection of photographs for the Avon Corporation in collaboration with Shelley Rice. The collection, entitled *Eye of the Beholder,* was exhibited at the International Center of Photography in 1997.

George Forss
c/o Ginofor Gallery
38 West Main Street
Cambridge, NY 12816

George Forss is a self-taught photographer whose work has been exhibited and published extensively in the United States and abroad. Forss has consistently expanded his photographic horizons with exhibitions at the Brooklyn Museum (1984) through shows at the Grenoble and Orangerie Museums in France (1994). Currently, he is working on a new book of New York City photographs, tentatively titled *Access,* that will feature images from private and forbidden locations throughout New York.

Susan Fowler-Gallagher
Route 1 Box 98
Staasburg, NY 12580

Susan Fowler-Gallagher became a professional photographer in 1976. Her first book, *Inside Las Vegas,* received a Silver Medal from the New Jersey Art Directors' Club in 1977 with an exhibition of the photographs held at the O.K. Harris Gallery in 1978. Her second book, *A Stranger in the House,* was published in 1978 with a solo show of the photographs at the 415 Gallery in New York City. Fowler-Gallagher's work has also been included in many other group and solo shows.

Roger Freeman
1620 Moland Road
Alfred Station, NY 14803

Roger Freeman graduated with an M.S. degree from the Institute of Design, Illinois Institute of Technology, and currently is professor of photography in the Department of Art and Design at the New York State College of Ceramics at Alfred University. Freeman's many solo shows include exhibitions at James Madison University (Harrisburg, Virginia) and Second Street Gallery (Charlottesville, Virginia); he has participated in many group exhibitions. His work appears in various collections, including the Bibliothèque Nationale (Paris), the Museum of Art (New Orleans, LA), and the Museum of Fine Arts (Houston, TX).

Per Fronth
c/o Throckmorton Fine Art
153 East 61st Street
New York, NY 10021

Per Fronth, born in 1963 in Kristiansand, Norway, is a self-taught photographer. Along with many solo shows in New York and Norway, Fronth has also exhibited work in numerous group exhibitions throughout the world. His work appears in many collections, including the Museum of Modern Art (Wakayama, Japan) and Nikon Interfoto (Norway). In 1997, he received the Norwegian Photojournalist Association Picture of the Year award for *Xingu Chief.* He is represented in New York by Throckmorton Fine Art.

Flor Garduño
c/o Throckmorton Fine Art
153 East 61st Street
New York, NY 10021

Flor Garduño studied at the Escuela Nacional de Aries Plasticas in Mexico City. In 1979, she became an assistant to Manuel Alvarez Bravo. Between 1981 and 1982, she traveled with a team to photograph rural villages throughout Mexico for reading primers published by the Secretariat of Education for Indigenous Communities. Garduño has exhibited and been published extensively, with solo shows in museums in Paris, Rotterdam, Chicago, and Montreal. Her work appears in many collections, including the Museum of Modern Art (New York) and Bibliothèque Nationale (Paris). She is represented in New York by Throckmorton Fine Art.

Patricia Germani
29 Boniello Drive
Mahopac, NY 10541

Patricia Germani received her B.S. from SUNY Oneonta in 1983 and shortly thereafter began studying non-silver photography. Germani has now worked with non-silver/alternative process printing for over a decade. Her platinum work has been exhibited, published, and collected throughout the United States. Since 1994 she has taught workshops in non-silver/alternative process photography at the International Center of Photography in New York City.

Peter Goin
Art Dept./mail stop #224
University of Nevada, Reno
Reno, NV 895557

Peter Goin is a professor of art in photography and video at the University of Nevada, Reno. He is the author of four books and served as editor of a fifth. His photographs have been exhibited in more than fifty museums nationally and internationally. He has received two National Endowment for the Arts Fellowships (1982 and 1990). Goin lives in Reno, Nevada.

Earl McAlan Greene, Jr.
43 Linnaean Street Apt. 25
Cambridge, MA 02138

Earl McAlan Greene, Jr. was born 1963 in Jacksonville, Florida. He received his M.F.A. in 1995 from the University of Illinois, Urbana-Champaign. His solo exhibitions include the UCAL-Berkeley Extension Center, San Francisco; I-Space Gallery, Chicago; Espace des Arts Plastiques, Saint-Die, France; and E.J. Bellocq Gallery, Ruston, Louisiana. His group exhibitions include the Association Grand Format, Colmar, France. Greene presently teaches photographic workshops in the Boston metropolitan area. *Sullivan Flyleaf* is from a larger series titled *Founding Fathers.*

Siegfried Halus
307 Lomita Street
Sante Fe, NM 87501

Austrian-born photographer Siegfried Halus was on the faculty of the fine arts department at the University of Connecticut, at Storrs, from 1973 to 1979; he headed the photography program at the

Boston Museum School from 1979 to 1993. His extended body of work, known as the *Flashlight Series,* has been exhibited and published widely in the United States and Europe, with featured portfolios appearing in *Aperture.* His recent book, *Living Shrines,* was published by the Museum of New Mexico Press in 1998. Halus currently teaches photography at Santa Fe Community College where he now heads the art department.

Judith Harold-Steinhauser

Judith Harold-Steinhauser studied with Oscar Bailey and Aaron Siskind at the Institute of Design in Chicago. Harold-Steinhauser has received numerous fellowships. Her work has been exhibited nationally and internationally and is held by many major collections that include the National Gallery of Canada, the Philadelphia Museum of Art, and the Smithsonian Institute. Her abiding interest in people and the ways in which they reveal themselves continues to provide a psychological center for a long-standing experimentation with photographic materials.

Joan Harrison
99 McLoughlin Street
Glen Cove, NY 11542

Joan Harrison, born in 1950 in New York, specializes in still life, portraiture, and imaging that breaks the boundaries between photography, collage, and drawing. Recently she has worked with projects for the Internet. Mentored by photographer Arthur Leipzig, Harrison followed his footsteps into teaching and now is a full professor of art at the C.W. Post Campus of Long Island University. Harrison has been awarded grants from Kodak and the Polaroid Corporation and has exhibited nationally.

Forrest Libero Holzapfel
P.O. Box 62
Rhinecliff, NY 12574

Forrest Holzapfel has been photographing for *TERRAIN: Remnants of Nineteenth-Century Industry* for almost four years. Beginning in New York's Hudson River Valley during his final year at Bard College, these images honor the historical relationship between the human and the natural world. The representational fidelity of these 8"-by-10" contact prints creates a visual archeology of each site. He presented a solo exhibition of forty-five prints in February 1999 at the Slater Mill Historic Site in Pawtucket, Rhode Island.

Andreas Horvath
Schwarzenbergpromenade 60
A - 5026, Salzburg

Andreas Horvath was born in 1968 in Salzburg, Austria. He worked with American photographer Ernestine Ruben, who introduced him to fine-art photography. After an education at a Viennese photo school, he published *Cowboys and Indians* a book about the American Midwest, praised by Richard Avedon. He has completed another project on Jacutia, Siberia. In addition to freelancing, Horvath teaches photography and creates experimental short films.

Kathryn Hunter
PO Box 330
Salisbury Mills, NY 12577

Kathryn Hunter's work with photography began in the early 1980s while she pursued her degree in English literature. While experimenting with various photographic techniques and films, she became intrigued with the qualities of infrared film. Since then, she has worked almost exclusively with it, though she is now making a transition toward digital imaging. Her work has been exhibited in numerous national exhibitions and in Rockport Publishers' *The Art of Enhanced Photography.*

Graciela Iturbide
c/o Throckmorton Fine Art
153 East 61st Street
New York, NY 10021

Graciela Iturbide, born in Mexico in 1942, worked as an assistant to Manuel Alvarez Bravo while studying film at the University Center of Cinemagraphic Studies in Mexico City. Iturbide became committed to documenting the indigenous people of Mexico. Since 1975, Iturbide has exhibited in more than sixty group shows throughout the world and in many solo shows, including the Museum of Modern Art in New York and the George Pompidou Center in Paris. In addition to the prestigious W. Eugene Smith Grant in Humanistic Photography (1987), Iturbide has received many grants, including a Guggenheim (1988). She is represented in New York by Throckmorton Fine Art.

William Jaeger
1154 Brookview Station Road
Castleton, NY 12033

William Jaeger is a photographer and writer living in upstate New York, where he has been photographing for twenty years.

Christopher James
Box 399 Main Street
Dublin, NH 03444

Artist and photographer Christopher James's paintings and photographic images have been shown for over thirty years in galleries and museums in the United States and abroad, including shows in the Museum of Modern Art, the Metropolitan Museum of Art, Eastman House, and galleries that include Witkin (NYC), Michelle Chomette (Paris), and Weston (Carmel, CA). His work has been published extensively in books and magazines, including *Aperture, Camera,* and *Harvard Magazine.* James currently is a professor and department chair at the Art Institute of Boston.

Václav Jirásek
Milesovska 10
130 00 Praha 3
Czech Republic

Born in Kaviná, Václav Jirásek studied painting at the Academy of Fine Arts and became a founding member of the artists' group Bratrstvo (Brotherhood) (1989-1994), which worked in the field of gesamtkunstwerk. Jirásek has exhibited widely throughout Europe and appears in numerous collections, including the Art Institute of Chicago and Umprum Museum (Prague).

Tatana Kellner
Rd1 Box 290
Rosendale, NY 12472

Tatana Kellner immigrated to the United States from Prague in 1969, holds an M.F.A. from the Rochester Institute of Technology (1974), and is cofounder and artistic director of the Women's Studio Workshop in Rosendale, New York. She has exhibited extensively and is represented by the Goldstrom Gallery in New York City. Kellner received a New York Foundation on the Arts Individual Fellowship (1997), and she has been an artist in residence at the MacDowell Colony, Yaddo, Lightwork, Visual Studies Workshop, and many others. Kellner also has authored eleven artist's books.

Gerardo Montiel Klint
Tecorral #26
Col. Club de Golf Mexico, Tlalpan
Mexico City, Mexico

Gerardo Montiel Klint studied photography at Centro de la Imagen and Escuela Activa de Fotografia, Mexico City. He received the 1996-1997 Young Creators Fellowship from the National Fund for Culture and Arts. Klint has had five solo exhibitions, the last one *Transmigracion* at Centro de la Imogen. His work has been published internationally and appears in various collections, including the San Francisco Camera Works fine-print program (San Francisco).

Robert Kozma
37 Old State Road
Wappingers Falls, NY 12590

After studying drawing and sculpture, Robert Kozma received a B.F.A. in Photography from S.U.N.Y. at Purchase. A recipient of a Guggenheim Fellowship (1990), his work is included in private and public collections that include MoMA and the Metropolitan Museum of Art. His principal technique is palladium printing, a process known for its rich, delicate separation of tone. Kozma currently teaches photography at Pratt Institute, Brooklyn, and at the State University of New York at Purchase.

Jeannette Claire Landrie
20 Blue Bell Road
Worcester, MA 01606-1566

Jeannette Claire Landrie received her B.A. in photography from Southern Illinois University, Carbondale, Illinois, in 1985. She currently works as a Biomedical Imaging Specialist at the University of Massachusetts Medical School while completing her M.Ed. at Curry College in Milton, Massachusetts. A recipient of a Massachusetts Arts Lottery Grant and a Houston Center for Photography Fellowship, her work has been included in many exhibitions and private collections and in the collection of the Museum of Fine Arts, Houston.

Dick Lane
1314 Paxton Avenue
Arlington, TX 76013

Dick Lane received his M.F.A. from the University of Florida (1985), and he currently is an instructor of photography and lab coordinator at Texas Christian University in Fort Worth, Texas. Lane's work has

appeared in many solo exhibitions and has been included in more than thirty group exhibitions. His work appears in museum and private collections throughout the United States. The Handley-Hicks gallery in Fort Worth, Texas, represents him.

Lawrence Lewis
17 Mountain View Avenue
Kingston, NY 12401

Lawrence Lewis received his M.F.A. from the Milton Avery Graduate School of the Arts at Bard College. Lewis is the Assistant Director at the Center for Photography at Woodstock, New York, and is a professor of photography at Marist College in Poughkeepsie, New York. His visual work includes photographic portraits of his family and friends, landscapes, and magical images of children at play. He lives in the Hudson Valley.

Eric Lindbloom
133 College Avenue
Poughkeepsie, NY 12603

Eric Lindbloom lives in Poughkeepsie, New York. He received an Individual Artists Fellowship in 1981 from the New York State Council on the Arts. *Angels at the Arno,* his monograph of photographs of Florence, Italy, was published by David R. Godine (Boston, 1994). Recent solo shows of his work appeared at Gallery 292 (New York City) and Donskoj & Co. (Kingston, NY). Lindbloom's photographs appear in numerous public collections, including the Bibliothèque Nationale (Paris), the Alinari Museum (Florence), and the Museum of Fine Arts (Houston).

Donald Lokuta
384 Huguenot Avenue
Union, NJ 07803

Donald Lokuta, born in the United States, studied photography at the Ohio State University where he received his Ph.D. Awarded nine grants for his photography, his images have been included in more than 300 exhibitions. Represented in many public and private art collections, Lokuta has authored or coauthored three books, and he has written many articles. Lokuta's photographs are video-still images freezing time in order to reveal an unseen world in evocative and mysterious images. Sarah Morthland Gallery in New York City represents him.

Tanya Marcuse
PO Box 364
Tivoli, NY 12583

Tanya Marcuse received her M.F.A. in photography from the Yale University School of Art (1990). Her photographs have been exhibited in museums and galleries throughout the country. She has received grants and awards that include a Thomas J. Watson Fellowship, the George Sakier Memorial Prize for Excellence in Photography from Yale, and a National Foundation for the Advancement in the Arts Award. Marcuse currently is assistant professor of photography at SUNY Dutchess Community College.

Richard Margolis
225 Barrington Street
Rochester, NY 14607

Since he began exhibiting his work in 1975 at the New England School of Photography, Richard Margolis has had over seventy solo shows. His prints appear in dozens of public and private collections, including the Bibliothèque Nationale in Paris, the Museum of Modern Art, the Polaroid Collection, and the Victoria and Albert Museum in London. His photographs also have been published in numerous magazines including *Picture Magazine #4, FOTOFOLIO, American Photographer,* and *Creative Camera,* and they have been exhibited in numerous group shows.

Joe Marotta
Art Department, AAC 161
University of Utah
Salt Lake City, Utah 84112

Joe Marotta completed his M.F.A. at Arizona State University and currently is an associate professor and former chairperson of the Art Department at the University of Utah. His nationally and internationally exhibited work is included in numerous public and private collections, including the Center for Creative Photography (Tucson), the Bibliothèque Nationale (Paris), the Portland Museum of Art (ME), and the Utah Museum of Fine Arts (Salt Lake City).

Fredrik Marsh
109 Westwood Road
Columbus, OH 43214

Fredrik Marsh was born in Quantico, Virginia, in 1957. He currently lives in Columbus, Ohio, where he has been teaching photography and computer art at Otterbein College since 1992. His work has

been included in numerous solo, competitive, and invitational exhibitions across the country since 1978. Marsh received an Arts Midwest/Regional National Endowment for the Arts Fellowship in 1985 and an Individual Artist Fellowship in Photography from the Ohio Arts Council in 1991.

Dan McCormack
13 Beehive Road
Accord, NY 12404

Dan McCormack, an active photographer and teacher for thirty years, earned degrees from the Institute of Design and the Art Institute of Chicago. One of the founding directors of the Center for Photography at Woodstock, he served on its board for ten years. *Bodylight: Passages in a Relationship,* his monograph of infrared images, was published in 1989 simultaneous with an NYSCA-CAPS Photography Fellowship. He currently heads the photography program at Marist College in Poughkeepsie, New York.

Anne Arden McDonald
247 Water Street #5C
Brooklyn, NY 11201

Anne Arden McDonald was born in London, England, and grew up in Atlanta, Georgia. From age fifteen to thirty, she made self-portraits and created private performances for her camera by building installations in the landscape or in abandoned interiors. In the past ten years, she has had thirty solo exhibitions in ten countries and has been published extensively, including most recently in *Aperture Magazine.* Her work is in the collections of five major museums, including the Brooklyn Museum, the Denver Museum, and the Bibliothèque Nationale.

Javier Silva Meinel
c/o Throckmorton Fine Art
153 East 61st Street
New York, NY 10021

Javier Silva Meinel started working as a photographer in 1973. One of the founding members of Secuencia Fotogaleria, he received a Guggenheim Fellowship in 1990 for his work about Andean ritual practices that was featured in *El Libro de los Encantados* (1993). More recently he published *Acho, altar de arena* (1993), about the bullfighting backstage of Lima. He currently is preparing a third book that will include images from the Qollor-Ritti pilgrimage in the Cuzco highlands. Meinel has had solo shows and has participated in group shows throughout the world. He is represented in New York by Throckmorton Fine Art.

Arno Rafael Minkkinen
One White Oak
Andover, MA 01810

Arno Rafael Minkkinen is a Finnish-American photographer who has worked with the self-portrait nude in the landscape since 1971. He studied with Harry Callahan and Aaron Siskind at the Rhode Island School of Design. He has also produced self-portraits with his wife and son as well as self-portraits with other women. Finland, New England, and the American Southwest have been his hunting grounds. Monographs include *Frostbite* (Morgan & Morgan, 1978), *Waterline* (Aperture, 1994), *Ten Minutes Past Midnight* (Musta Taide, Helsinki, 1998), and *Body Land* (Smithsonian Press, 1999). Minkkinen is represented by Barry Friedman, Ltd. (New York), Nathalie C. Emprin (Paris), and Photo & Co. (Turin, Italy).

Susan Moldenhauer
1206 S. 11th Street
Laramie, Wyoming 82070

Susan Moldenhauer has been working with fabrics since 1981 as a method of creating poetic, lyrical, and personal images in landscape or indoor settings. The landscape of the American West has dominated her work since 1988. She received her M.F.A. in photography from Penn State University in 1982, has had many solo and group exhibitions throughout the United States, and is represented in many public and private collections. Moldenhauer lives and works in Wyoming.

Ann Morse
RR2 Box 130
Millbrook, NY 12545

Ann Morse is a graduate of Vassar College, is a Fellow of Photography at the Museum of Modern Art (NYC), and is on the advisory boards of Bard College (Annandale, NY), Vassar College (Poughkeepsie, NY), and the Center for Photography at Woodstock (Woodstock, NY). Her widely published work has appeared in more than twelve solo shows and over fifty group exhibitions.

Ardine Nelson
109 Westwood Road
Columbus, OH 43214

Ardine Nelson, born in Chicago, Illinois, teaches photography at Ohio State University. Her work has been included in solo, competitive, and invitational exhibitions since 1972. Nelson participated in the Polaroid Grant Program from 1978 to 1983, received a Greater Columbus Arts Council Grant in 1990, and won an Ohio Arts Council Fellowship in 1991. She was chosen as Artist in Residence, Luis Cernuda Fundacion, Sevilla/Utrara Spain, spring 1992. Nelson's Diana camera images represent a consistent vision of the landscape.

Tamaki Obuchi
5-3, Takahadai, Shui
Kokura Minami
Kitakyushu Fukuoka 803-0985, Japan

Tamaki Obuchi studied the history of art and Japanese painting while in college. Deeply impressed by Imogen Cunningham's black-and-white photographs in 1991, he turned his work to fine-art photography. His goal is to photograph not only visible things, but also intangible elements that might lie beyond them. He wants his work to express something spiritual as well as physical.

Masahiro Oku
1-5-24 Noma Minami-ku
Fukuoka 815-0041
Japan

Masahiro Oku works as a portrait photographer in his studio in Noma Minami-ku, Fukuoka. He photographs for magazines, and he works as a curator of photo exhibitions by young, local photographers. He has had more than ten solo exhibitions, and his work has been published extensively. He is a member of the Nihon Shashin Kyokai Foundation and is chairman of the Fukuoka Contemporary Photographers Committee. Recently, he started to teach photo workshops at Gallery-GEN in Fukuoka.

Olivia Parker
229 Summer Street
Manchester, MA 01944

A photographer since 1970, Olivia Parker has had more than 100 solo exhibitions in the United States and abroad. Her work is represented in major private, corporate, and museum collections. *Art News, American Photographer, Camera,* and numerous other magazines have published portfolios of her work, and three monographs focused on her photographs. In 1996, she received a Wellesley College Alumnae Achievement Award. Residencies include Dartmouth College (1988), the MacDowell Colony (1993), and the Isabella Stewart Gardner Museum (1997).

Pavel Pecha
Botanicka 23
917-08 Trnava
Slovakia

Pavel Pecha was born in Kremnica, Slovakia, and graduated from the Institute of Artistic Photography in Opava, Czechoslovakia, and the department of photography, FAMU (Prague's Film Academy/Prague). Pecha has had numerous solo and group exhibitions of his work in Europe the United States.

Helene Penn
2 Twin Ponds Drive
Bedfor Hills, NY 10507

Helene Penn has been a fine-art photographer for more than twenty years. A graduate of Cornell and Columbia Universities, her work has concentrated on landscape, architectural, and still-life subjects. She has exhibited in numerous galleries and museums. Many corporate, private, and institutional collectors hold her work. Penn is currently exploring the application of digital tools to her images.

Ivan Pinkava
Jenštejnská 3
Prague
Czech Republic
12000

Ivan Pinkava was born in Nachad, Czechoslovakia, and studied art photography at Prague's Film Academy (FAMU). He was a part-time teacher at FAMU; he became a member of the board of directors of the Prague House of Photography and since 1994 has been a member of the NOX agency. He lives and works in Prague, Czech Republic. Since 1988, his work has been exhibited throughout Europe and the United States, and his prints have been included in private and public collections all over the world.

Rudo Prekop
Slezska 117
13000 Praha 3
Czech Republic

Rudo Prekop was born in Kosice, in Eastern Slovakia, Czechoslovakia. He currently teaches at the department of photography, FAMU (Prague's Film Academy). Prekop has had fifteen solo exhibitions of his work in the United States and Europe and has participated in more than seventy-five group exhibitions. His work is represented in numerous public and private collections, including the Slovak National Gallery (Bratislva, Slovakia), the Bibliothèque Nationale (Paris), and the Musee de la photo (Arles, France).

Renata Rainer
11 Cottontail Lane
Irvington, NY 10533

Renata Rainer, artist and photographer, is a veteran of many solo and group shows. Her layered images, melding elements of nature and culture, characterize her recent work. As curator, she has won acclaim for exhibits that illuminate past and present camera work. She currently is adjunct associate professor of photography at Manhattanville College and has been a frequent lecturer on the history of photography, sponsored by the New York Council for the Humanities.

Lilo Raymond
56 Cutler Hill Road
Eddyville, NY 12401

Lilo Raymond was born in Germany and currently lives in New York City where she teaches workshops and photographs commercially. Raymond's images have been exhibited in numerous solo and group exhibitions and appear in many major collections, including the Metropolitan Museum of Art (NYC), the Bibliothèque Nationale (Paris), the Museum of Modern Art (NYC), and the National Gallery of Art. Extensively published, Raymond's images have been presented in the monograph *Revealing Light* (Little, Brown, 1989).

Anita Ricardo
90 Cedar Avenue
Maywood, NJ 07607

Anita Ricardo is a freelance photographer whose subjects include the nude, still life, and photo essay. Primarily self-taught in photography, she has taken a background in research, a psychology degree, and a lifelong interest in art to create a visual dialogue through the interaction between a structured physical world and an inner transcendent nature. She has lectured on photography at several local colleges. Recently, she presented her photo essay on Alzheimer's disease at a national teleconference.

James Riegel
915 Reed Street
Kalamazoo, MI 49001

James Riegel was born 1945 in Kalamazoo, Michigan, where he still resides. He studied art at Kendall School of Design in Grand Rapids, Michigan, but is self-taught in photography. He has been photographing and exhibiting the nude since 1974. Since 1984, he has chaired the photography department at the Kalamazoo Institute of Arts in Kalamazoo, Michigan.

Ernestine Ruben
644 Pretty Brook Road
Princeton, NJ 08540

Ernestine Ruben is internationally known through extensive exhibitions, books, and workshops. Her work is included extensively in major museum and private collections. She has photographed the human body for years. She now applies her love of life and human spirit to landscapes and architecture. Her work is represented, among others, by the Platinum Gallery (New York), Gallerie Baaudoin Lebon (Paris), and Paul Cava Fine Art (Philadelphia).

Janet Russek
369 Montezuma
Suite 345
Santa Fe, NM 87501

Janet Russek lives in Santa Fe and collaborated with her husband, photographer David Scheinbaum, on *Ghost Ranch; Land of Light* (Balcony Press, 1987). She was Eliot Porter's assistant from 1980 until his death in 1990. Her work has been exhibited nationally and internationally. Museum collections that contain her work include the Museum of Fine Arts (Santa Fe), the Bibliothèque Nationale (Paris), the Chase Manhattan Bank Collection (New York), and the Gernsheim Collection (Harry Ransom Humanities Research Center, University of Texas at Austin).

Tom Santelli
4 Glendale Avenue
Delmar, NY 12054

Tom Santelli graduated from the High School of Art and Design in Manhattan and continued on to receive a B.F.A. from Pratt Institute and an M.F.A. from the Rochester Institute of Technology. He currently heads the photography program as an assistant professor at the College of Saint Rose in Albany, New York. His photographic work has been displayed in numerous juried exhibitions, and several images have been published by Warner Books, Inc. and Photo Metro.

John Scarlata
PO Box 797
Valle Crucis, NC 28691

John Scarlata received his M.F.A. from the California Institute of the Arts in 1976. He has taught photography at Penland School in North Carolina and the University of North Carolina at Charlotte. He currently is professor of photography at Virginia Intermont College in Bristol, Virginia. His work has been exhibited in numerous group and solo shows in the United States, and it is represented in the collections of many southeastern public and private institutions.

Roberto Schezen
Roberto Schezen/co Tanya Murray
Edwynn Houk Gallery
745 Fifth Avenue
New York, NY 10151

Italian-born Roberto Schezen is known primarily for his photographs of architecture. During the past ten years, he has published several books that highlight the architectural splendors of Italy, France, and Spain, as well as the ancient temples of Mexico and Central America. He has also photographed architectural masterpieces of the modernist era, the great houses of Newport and Palm Beach, and the Greek-revival statues of male athletes in the Marble Stadium and Palazzo della Civilta Romana in Rome.

Bastienne Schmidt
c/o Throckmorton Fine Art
153 East 61st Street
New York, NY 10021

Bastienne Schmidt studied anthropology at the Ludwig-Maximilans-Universitaet in Munich before moving to Italy where she studied painting and photography at the Academia di Belle Arti Pietro Vanucci. Schmidt has exhibited widely, and her work is housed in many public collections, including the Museum of Modern Art, the Brooklyn Museum, the Bibliothèque Nationale (Paris), and Fotografiska Museet (Stockholm). Among others, she has received awards from the Academy of Fine Arts, Ban, Italy, and the Photofoerderpreis from the Landesgirolkasse Stuttgart. She is represented in New York by Throckmorton Fine Art.

J. Seeley
59 South Road
Portland, CT 06480

J. Seeley studied with Oscar Bailey, Charles Swedlund, and later with Harry Callahan at the Rhode Island School of Design where he received his M.F.A. His work has been exhibited in the United States and Europe and has been widely published. Seeley is the author of *High Contrast* (Focal Press, 1992, 2nd edition). Seeley has taught at Wesleyan University in Connecticut since 1972 where he is the director of the art program. He currently explores digital collage and inkjet printing.

Vincent Serbin
Image Garden Studios
8 Orchard Lane
Woodstock, NY 12498

Vincent Serbin's photographs have been featured in nearly 100 group and solo exhibitions across the United States. He has created multiple-image photographs since 1978, and his work has won numerous awards. Using negative collages, multiple-image printing, set construction, and more, Serbin creates unique representations connected to a mythic world.

Ken Shung
41 Union Square West
#735
NY, NY 10003

Ken Shung has been internationally published in numerous magazines, including *Rolling Stone, New York Times Magazine, Interview, GQ, Discover, Money, Mirabella,* and *Vanity Fair.* He received a Distinctive Merit award in APA's awards book volume 2, a Photo District News/ Nikon self-promotion award in 1988 and 1991, and an Art Directors Club award shared with Duane Michaels. Shung currently is working with a writer on a book about adopted families. He lives in Manhattan and upstate New York.

Ann Simmons-Myers
819 North Fourth Ave.
Tucson, AZ 85705

Ann Simmons-Myers's work has appeared in numerous publications, including *New American Nudes and Arizona: The Land and the People.* She has received grants from the Arizona Commission on the Arts, the Phoenix Art Museum, and other institutions. Simmons-Myers's prints are represented in museum collections, including the Museum of Fine Arts (Houston), the Los Angeles County Museum, and the Center for Creative Photography (Tucson), Simmons-Myers heads the photography program at Pima College in Tucson, Arizona.

Oren Slor
509 11th Street
Brooklyn, NY 11215

Born in Israel in 1957, Oren Slor studied advanced black-and-white photography with Simcha Shirman at Camera Obscura in Tel-Aviv from 1979 to 1980. After moving to the United States in 1980, Slor studied art as a photo major at the Art Academy of Cincinnati, where he received his B.F.A. He received his M.F.A. from Pratt Institute in 1987. Slor's first solo exhibit was at the Center for Photography at Woodstock in 1996.

Len Speier
190 Riverside Drive
New York, NY 10024

Len Speier is a native New Yorker whose work is in permanent collections that include the International Center for Photography (NYC), the Bibliothèque Nationale (Paris), and the Museum of the City of New York. He exhibits in the United States and abroad; former clients include ABC TV, *Forbes,* Fuji, Met Life, Random House, Transamerica, and Weight Watchers. An associate professor at the Fashion Institute of Technology, he also manages a minicareer as an attorney involved in artists' rights.

Harvey Stein
755 West End Avenue
New York, NY 10025

Harvey Stein is a professional photographer, teacher, and author. He currently teaches at the International Center of Photography, the New School for Social Research, and Drew University. Stein's work has been the focus of three major books, the most recent of which is *Coney Island* (Norton, 1998). Published extensively, his photographs appear in more than thirty public and numerous private collections. Throckmorton Fine Art and Photocollect, New York City, and the Susan Spiritus Gallery, Newport Beach, California, among others, represent his work.

Jim Stone
1044 Stanford Drive NE
Albuquerque, NM 87106

Jim Stone is a photographer, teacher, author, and editor. His photographs have been exhibited and published internationally and have been collected by the Museum of Modern Art, Boston's Museum of Fine Arts, the National Museum of American Art, and many others. Three of his books, including *A User's Guide to the View Camera,* are used for university-level courses. An artist's book of his photographs, *Stranger Than Fiction,* was published in 1993 by Light Work. He currently is assistant professor of photography at the University of New Mexico.

Gerardo Suter
c/o Throckmorton Fine Art
153 East 61st Street
New York, NY 10021

Gerardo Suter was born in Argentina in 1957 and has lived in Mexico since 1970. Largely self-taught, his first mature works, *El archivo fotografico del profesor Retus (The Photographic Archive of Professor Retus),* explored themes of memory, nostalgia, and the persistence of the past in mysterious scenes of pre-Columbian architectural remains. Suter's work has been exhibited and published by numerous museums and publications throughout Latin America, Europe, and the United States. He is represented in New York by Throckmorton Fine Art.

Miro Švolik
Chvalova 9
13000 Praha 3
Czech Republic

A Czech citizen since 1993, Miro Švolik graduated from FAMU in 1987. He is a freelance photographer and a member of the Action-Group of Free Photography and the NOX agency. He has taken part in many group exhibitions and has had solo shows at Tosca Dabac Archives in Zagreb (1985), the Robert Koch Gallery in San Francisco (1989), the Stuart Levy Gallery in New York (1991 and 1996), and the Prague House of Photography (1996). In 1990, he won the Young Photographer Prize of the International Center of Photography in New York.

Joy Taylor
RD#1 Box 95
Red Hook, NY 12571

Joy Taylor is a photographer and sculptor who lives in upstate New York. She often exhibits her work in New York City, where the Ubu Gallery represents her photographs. She is a former student of collage artist Romare Bearden, and she has received grants from the Pollock-Krasner Foundation and Women's Studio Workshop (New York).

Michael Teres
4322 Reservoir Road
Geneseo, NY 14454

Michael Teres was born in 1940 in Brooklyn, New York. His received his B.A. from Hunter College in NYC and his M.A. and M.F.A. from the University of Iowa. Teres teaches photography, computer art, and graphic design at the State University of New York at Geneseo, and desktop publishing at RIT. Michael's work is in several museum collections, including the San Francisco Museum of Modern Art, the International Museum of Photography at George Eastman House, and the Art Institute of Chicago.

Jerry Uelsmann
5701 SW 17th Drive
Gainesville, FL 32608

Over the past thirty years, Jerry Uelsmann has had more than 100 solo exhibitions in the United States and abroad. His work is included in major museums worldwide, including the Metropolitan Museum and the Museum of Modern Art (New York), the International Museum of Photography at the George Eastman House, the Victoria and Albert Museum (London), and the Bibliotèque Nationale (Paris). Over the past twenty-five years, nine books devoted to his art have been published. Uelsmann received a Guggenheim Fellowship in 1967 and a National Endowment for the Arts Fellowship in 1972. In 1997 he retired from the position of Graduate Research Professor at the University of Florida Department of Art.

Joris Van Daele
745 Rowntree Avenue
London Ont. N6C 2L9
Canada (519) 433-2929

Joris Van Daele began photographing at age thirteen and started working as a professional photographer at age seventeen. His first solo photographic exhibition was in 1969. He credits his love of ads to his parents and his technical skills to mentors with whom he worked when employed as a darkroom technician, reporter-photographer, and medical and commercial studio photographer. Van Daele's work has been exhibited in galleries and museums in Los Angeles, New York, Germany, and across Canada.

Kamil Varga
c/o Kozsypal
Veverkova 14
17000 Praha 7
Czech Republic

Kamil Varga is represented in the United States by Anne Arden McDonald

Joseph Vitone
4413 Avenue C
Austin, TX 78751

Joseph Vitone was born in Akron, Ohio. Since 1991, he has resided in Austin, Texas, where he is professor of photocommunications at St. Edward's University. Most of his work in the 1990s comprised views made in wilderness areas of the western United States. His recent photography focuses on agrarian aspects of Costa Rican society and on the economical and spiritual connectedness to the earth experienced there by many.

Sam Wang
PO Box 1624 Lane
Clemson, SC 29633

Sam Wang was born in China and grew up in Hong Kong. He received an M.F.A. in photography from the University of Iowa (1966) and has been teaching photography and digital imaging at Clemson University in South Carolina. His work includes many alternative processes in addition to straight black-and-white silver prints. He designed and built the camera for his circular images, making use of the entire image field of a rectilinear lens for an inclusive, confronting view.

Steve Weisberg
724 South Genesee Avenue #2
Los Angeles, CA 90036

After a career in music, Steve Weisberg returned to his roots as a visual artist. He studied photography with Peter Correia and went on to complete his degree at SUNY New Paltz. There he learned platinum printing in a workshop taught by James Luciana. This process formed the basis for most of his subsequent work: private portrait commissions, images published on dozens of CD covers, and his most recent series on the prostitutes of Mexico.

Roger Arrandale Williams
28 Pinebrook Drive
Morrisonville, NY 12962

Roger Arrandale Williams is a professor of art at the State University of New York in Plattsburgh, New York. During his twenty-five-year tenure at Plattsburgh, Williams has offered direction and substance to the program by teaching a full complement of courses in color and in black-and-white photography. His images have been shown nationally in more than 100 juried and invitational exhibitions, including thirty-five solo shows at art galleries and museums throughout the United States.

Peter Zupnik
9 rue Marcelia Berthelot
92/30 Issyles Molineaux
France

Peter Zupnik represented in the United States by Anne Arden McDonald

ACKNOWLEDGMENTS

I would like to express my appreciation to the talented and visionary artists whose work appears in these pages. Thanks also to the fine people at Rockport Publishers whose patience and support made this project a pleasurable one. Special thanks goes to Ellen Westbrook, my project manager, who allowed me to work through unavoidable delays and who approached everything with quiet good cheer. Of the many others who have allowed me the time and space to finish this brief but intense project, I must thank Kathryn, my wife, for her support and the time she spent reviewing images with me and then allowing me to resolve the sticky parts myself. Also, very special thanks to those artists who took the time to recommend other artists for this project. A photographer recommending other photographers was one of the most rewarding means of contact I could have asked for.

ABOUT THE AUTHOR

James Luciana received his Master of Fine Arts degree from Arizona State University and currently is an associate professor of art at Marist College where he chairs the Department of Art and Art History. He also teaches courses and workshops in non-silver/alternative processes and digital imaging at the International Center for Photography in New York.

Mr. Luciana's work has appeared in numerous solo shows and in more than seventy national and international group exhibitions. Most recently, his work has been added to the collections of the European Museum of Photography and the Bibliothèque Nationale in Paris.

Messenger Bound

James Luciana
5" x 4" (10 x 13 cm)
Platinum Print 1992

This book is dedicated to the memory of Shepard Coleman, master cellist and Tony award-winning musical director and conductor. A raconteur of the first order, he was a man who not only enjoyed a good conversation, but also followed it leisurely down whatever meandering path it decided to go. He was an artist, an intellectual, and a compassionate man with a big heart who hated to see an injustice go unpunished, a friend maligned, or an animal neglected. He was a gentleman, and he was a friend.